NEW YORK

THEN AND NOW®

First published in the United Kingdom in 2020 by
PAVILION BOOKS
an imprint of Pavilion Books Company Ltd.
43 Great Ormond Street, London WC1N 3HZ, UK

"Then and Now" is a registered trademark of Salamander
Books Limited, a division of Pavilion Books Group.

© 2020 Salamander Books Limited, a division of Pavilion
Books Group.

All notations of errors or omissions should be addressed to
Salamander Books, 43 Great Ormond Street, London WC1N
3HZ, UK

ISBN-13: 978-1-911624-74-5

Printed in Singapore

PICTURE CREDITS
Then Photographs:
The publisher would like to thank the following for supplying
archive photos for the book:
Alamy: pages 14, 18, 40, 42, 44, 52, 54, 58, 68, 72, 84, 92.
Color Press: pages 6, 7, 16, 28, 30, 48, 50, 60, 64, 70, 74, 76, 82, 90.
Getty Images: pages 12, 24, 46, 56, 66, 88, 94.
Library of Congress: pages 8, 10, 20, 22, 26, 32, 34, 78, 80, 86.
New York Public Library: pages 36, 62.

Now Photographs:
All photographs were taken by Karl Mondon with the
exception of the following:
Alamy: pages 9 13, 15, 17, 45, 49, 57, 59, 86.
Getty Images: page 89.
Hetty Hopkinson: page 71.
Evan Joseph / Pavilion Image Library: pages 69, 93.
David Watts / Pavilion Image Library: pages 35, 37, 39, 51.

Cover Image:
Wollman Ice-Rink, Central Park in 1969 by Getty Images.

NEW YORK

THEN AND NOW®

KARL MONDON
HETTY HOPKINSON

PAVILION

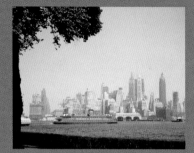
Lower Manhattan, c. 1958 p. 14

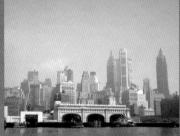
Ferry Terminals, 1962 p. 16

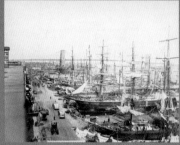
South Street Seaport, 1885 p. 26

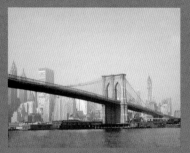
Brooklyn Bridge, 1961 p. 28

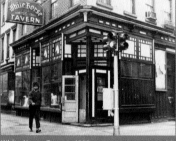
White Horse Tavern, 1955 p. 36

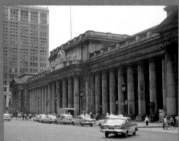
Penn Station, 1960 p. 40

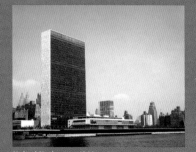
United Nations, c. 1960 p. 32

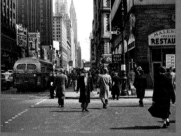
42nd Street, c. 1947 p. 50

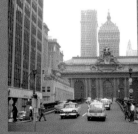
Grand Central Station, 1960 p. 52

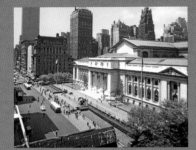

New York Public Library, 1951 p. 58

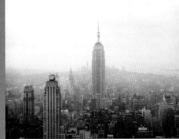

Empire State Building, 1959 p. 64

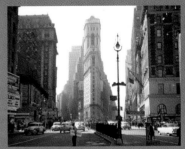

Times Square Looking South, c. 1955 p. 70

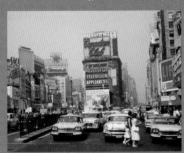

Times Square Looking North, 1959 p. 72

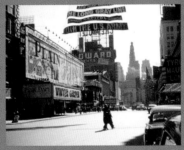

Winter Garden Theatre, 1955 p. 76

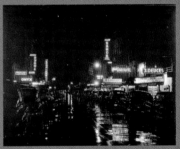

52nd Street Jazz Clubs, 1948 p. 78

Lincoln Center, c. 1958 p. 84

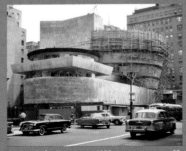

Guggenheim Museum c. 1959 p. 92

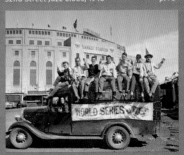

Yankee Stadium, 1952 p. 94

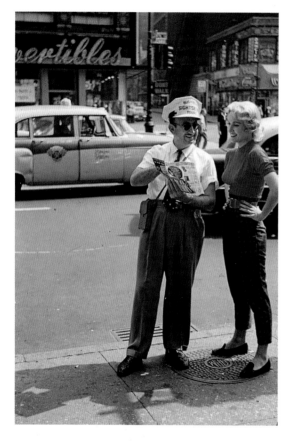

Frank Sinatra helped define New York as "the city that never sleeps" in his version of the Kander & Ebbs song, *New York, New York* (1977). And it's true. The Staten Island Ferry never stops running and the Subway runs for 24 hours. It's also a city that never stops developing.

From the earliest settlement when the wall that gave its name to Wall Street protected Dutch villagers on the tip of Manhattan, the city has marched north up the island. Little is left of colonial New York, though you can still find one example of a house where Alexander Hamilton made regular calls as a lawyer in this book. Likewise, the great mansions built by the industrial magnates of the Gilded Age—the Vanderbilts and the Astors—have all been swept aside as their sites became too valuable to remain as private residences.

Today, the amazing architecture of skyscrapers along 57th Street and the multi-billion dollar development of the Hudson Yards are pioneering a new race for the sky, first envisaged in the 1930s with the Chrysler Building, Rockefeller Center and Empire State Building.

While you will find a lot of comparisons between Victorian New York and the modern day in our companion title, *New York Then and Now* (Marcia Reiss), this edition uses many vintage color photos from the 1940s, 50s, 60s to show more recent changes. Lovers of the television series *Madmen* and *The Marvelous Mrs Maisel* will recognize the New York street scenes included here; a time when cabs were not all painted Dupont M6284 yellow (a rule instigated in 1967) and when tour guides wore high-waisted, gray flannel pants and instructive cream-colored peaked caps.

NEW YORK
THEN AND NOW INTRODUCTION

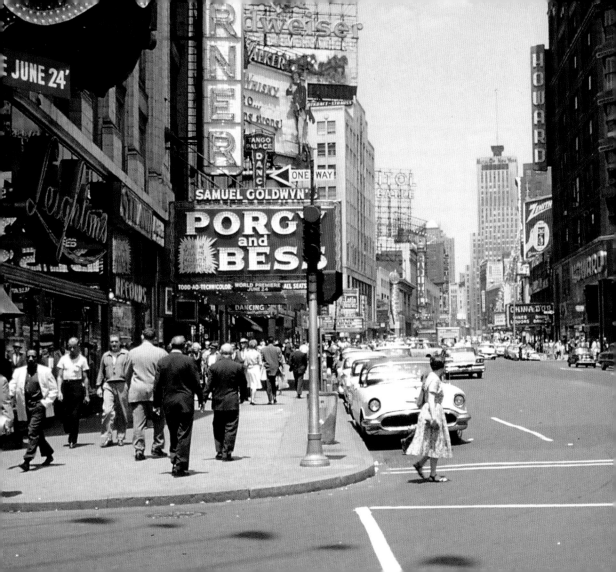

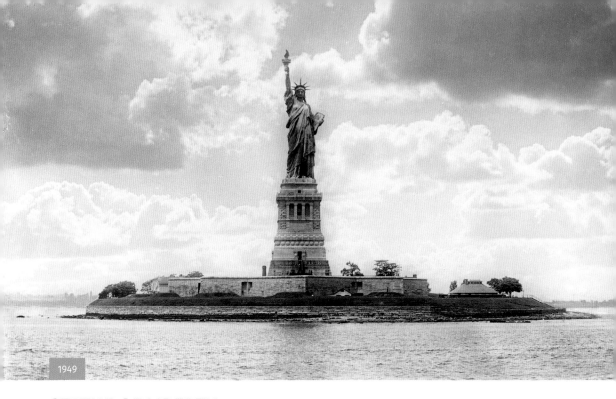

1949

STATUE OF LIBERTY
America's most recognizable icon is a French import

ABOVE: Taken in 1949, this photo shows how the Statue of Liberty would have appeared to those arriving into New York Harbor. Officially entitled *Liberty Enlightening the World*, it was created by sculptor Frédéric-Auguste Bartholdi, and gifted to America by France in 1884 to mark the American Centennial. The statue is Roman goddess of freedom Libertas, who holds a tablet with the date of the Declaration of Independence. The statue was constructed on top of the now obsolete Fort Wood, an eleven-pointed wall fortification built in 1806 on Bedloe Island to protect New York harbor. From 1892 to 1943 the statue greeted over twelve million immigrants as they arrived at Hudson River piers and were transported over to Ellis Island to begin the immigration process.

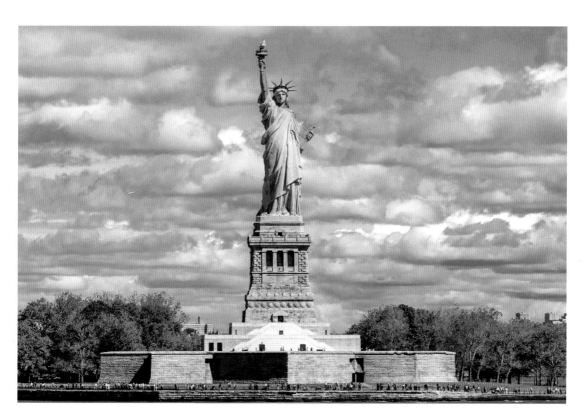

ABOVE: An Act of Congress renamed Bedloe Island as Liberty Island in 1956, and though "Lady Liberty" remains largely unchanged, the island has undergone development to accommodate increasing visitor numbers. In 1972 Richard Nixon presided over the opening of the American Museum of Immigration in the statue's base. The museum closed in 1991 following the opening of the Ellis Island Immigration Museum, and in 2016 work began on the new Statue of Liberty Museum. Opened in May 2019, the museum features exhibits relating to the construction and history of the statue, including the original torch, damaged by an explosion caused by German saboteurs in 1916 and replaced in 1985.

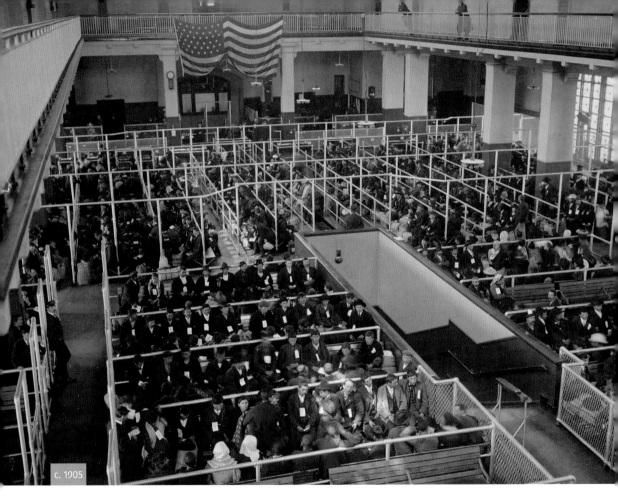

c. 1905

ELLIS ISLAND IMMIGRATION CENTER

"Give me your tired, your poor, your huddled masses yearning to breathe free"

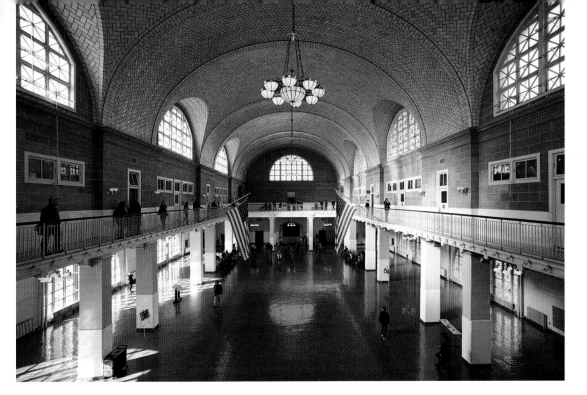

LEFT: When immigration came under control of the Federal Government in 1890, Ellis Island was chosen as the site of an immigration station. From January 1892, approximately 1.5 million immigrants were processed through the facility until its destruction by a fire in June 1897. A new, less flammable station opened in December 1900. This photo shows immigrants being processed through the Great Hall. Chalk was used to mark the clothing of those immigrants suffering from medical conditions, and around 20 per cent were detained. Immigrants could also be detained and deported if it was thought they would become financial burdens.

ABOVE: The Immigration Act of 1924 enacted stricter immigration quotas, leading to a large reduction in the number of immigrants permitted entrance to the U.S. Ellis Island was modified from a processing facility to an immigration-detention center; however the massive expenses needed for its upkeep led to its closure in 1954. It was replaced by a smaller facility on Manhattan. Following the station's closure, the buildings languished with little use until after a full renovation. The Ellis Island Immigration Museum opened on September 10, 1990.

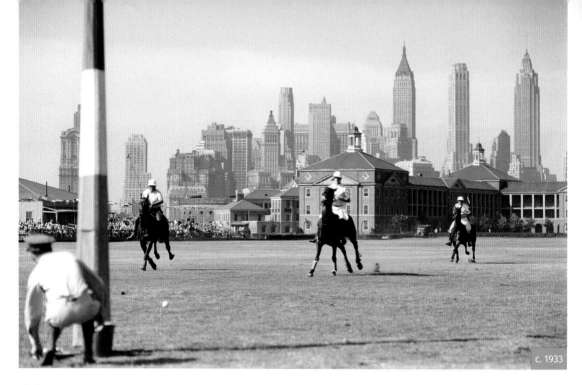

c. 1933

GOVERNORS ISLAND
The 172-acre island is steeped in history

ABOVE: Located at the mouth of the East River, Governors Island's military history stretches back to the Revolutionary War. Its fortifications were intended to protect Manhattan from the British but it was overrun in 1776 and remained in British hands until Evacuation Day in 1783. Though the forts no longer served a purpose by the 1830s, the island continued to operate as an administrative and training center for a peacetime U.S. Army. The presence of an army community meant various facilities were created to serve the island's military population. One popular sport was polo, and in 1920, a playing field was established on the island's Parade Ground. In this photo from circa 1933, Manhattan is visible behind the playing field, notably the Bank of Manhattan, the City Bank-Farmers Trust Building, and the Cities Service Building. Constructed during the New York skyscraper race, they dominated the downtown skyline in the 1930s.

ABOVE: The island served an important role during World War II, becoming headquarters of the U.S. First Army, who played a critical role in the planning of the D-Day invasion. In 1966, Governors Island was "reenlisted" with the U.S. Coast Guard. Until its final closure in 1996, it was one of the longest continually operating military installations in the country. It opened for public use in 2005, and now welcomes over 800,000 visitors a year between May and September, hosting free arts and cultural events. The 43-acre park includes several artificially installed hills rising up to 70 feet above sea level, pictured here with the Manhattan skyline in the background and two of the hi-rises from the 1930s still visible. The Slide Hill features New York City's longest slide, at 57 feet.

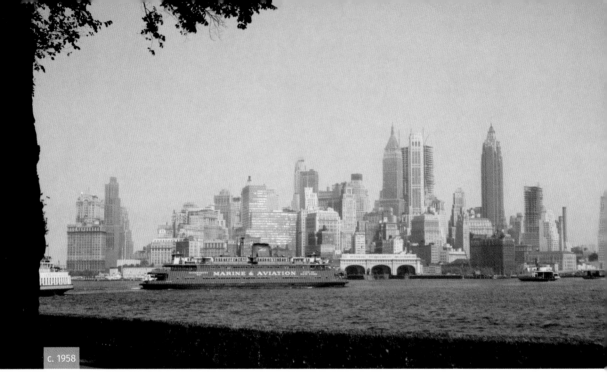

c. 1958

LOWER MANHATTAN

The 1950s view of Manhattan was similar to the 1930s view. It was all about to change . . .

ABOVE: This photo, taken from Governors Island in the late 1950s, shows a skyline relatively unchanged since the skyscraper boom of the early 1930s, culminating in 1931, a year in which 32 towers were completed. The Art Deco tapered tops and steel spires of many early skyscrapers reflected zoning requirements, which regulated the extent to which buildings prevented sunlight from reaching the streets below. The Cities Service Building, now known as 70 Pine Street, was the last skyscraper to be constructed in lower Manhattan prior to World War I, and the tallest until the completion of the World Trade Center. Construction began on One Chase Manhattan Plaza in 1956, just visible behind the Bank of Manhattan and the City Bank-Farmers Trust Buildings, and was completed in 1961. Also visible on the water is the Staten Island Ferry, then owned by the Department of Marine and Aviation.

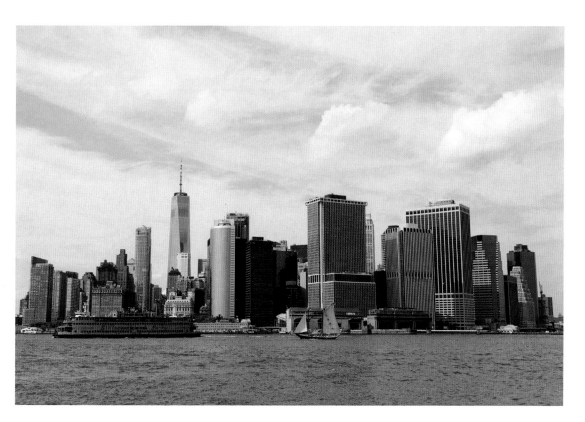

ABOVE: The construction of multiple new buildings near the waterfront has eliminated the gently sloping vista that drew onlookers' eyes to the downtown 1930s skyscrapers. Over half a century, lower Manhattan's skyline has evolved rapidly. Ground was broken on the new World Trade Center site in 1966, and on its completion in 1972, One World Trade Center became the world's tallest building. Following the devastating destruction of the Twin Towers, the 1776-foot Freedom Tower, was constructed on the site, opening in 2015. Other buildings that now occupy the skyline include 17 State Street, completed in 1988 with a distinctive curved glass façade, as well as 1 New York Plaza (completed 1969), 2 New York Plaza (1977), and 55 Water Street (1972), which now crowd the water's edge.

FERRY TERMINALS
The starting point for a ride to Staten Island

BELOW: The Staten Island Ferry originated in 1817 as a steamboat service operated by the Richmond Turnpike Company between Manhattan and Staten Island. The service was taken over by New York City in 1905, and ferries departed from the Whitehall Terminal, a Beaux-Arts-style building completed in 1903. Originally identical to the Municipal Ferry Pier to its right, a $3 million renovation in 1956 modernized the terminal, as seen in this 1962 photo. Completed in 1909, the Municipal Ferry Pier, now the Battery Maritime Building, ran ferry services between Manhattan and South Brooklyn before they were decommissioned in 1938. From 1956 the U.S. Army began to use the terminal to provide service to the Army post on Governors Island, and in 1959 the building came under the ownership of the Department of Marine and Aviation.

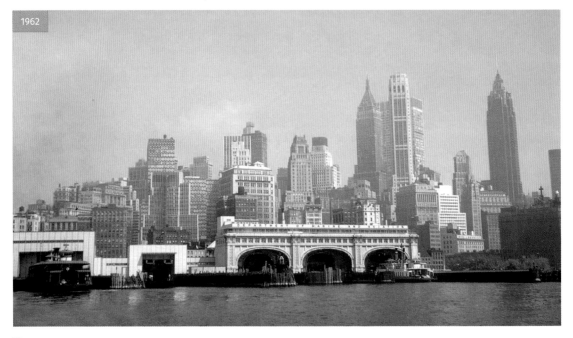

1962

BELOW: Destroyed by a fire in 1991, a completely renovated and modernized terminal opened on February 7, 2005 with connections to the New York City Subway. The ferry operates 24/7, and lack of transit connections between Manhattan and Staten Island means that the ferry still has a high commuter ridership. Since 1997, the route has been free, resulting in its popularity among tourists wishing to catch a free up-and-close glimpse of the Statue of Liberty. Though the United States Coast Guard left Governors Island in 1996, the Battery Maritime Building is still in use as a ferry terminal, operating a public ferry service to Governors Island between May and October.

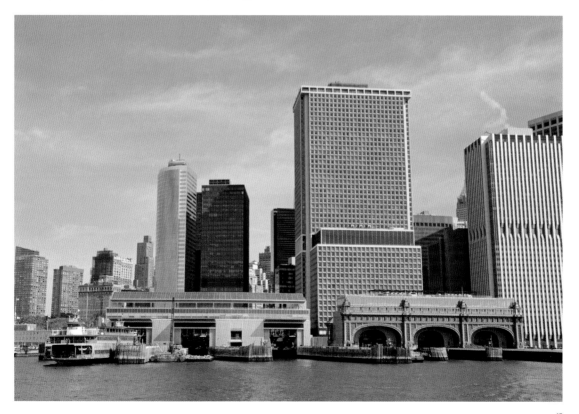

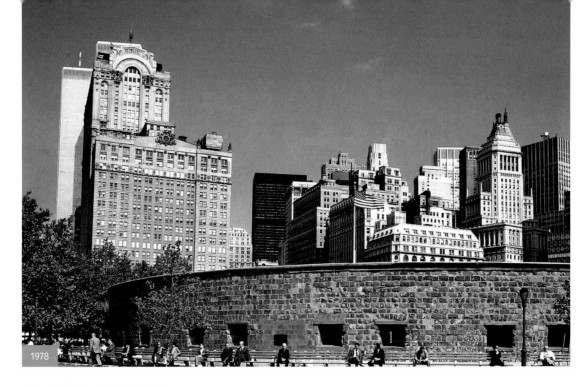

1978

CASTLE CLINTON

One of the few structures to survive two centuries of change in Lower Manhattan

ABOVE: Built in 1808 as a fort, once the War of 1812 with the British was concluded, Castle Clinton had very little defense work to do. Between 1855 and 1890 it functioned as the first official American Immigration Station, jointly operated by the City and State of New York. With no official point of entry before 1855, immigrants were free to disembark at various seaports along the east and west coasts. Between 1855 and 1890, however, states began to regulate their own immigration policy. During this time, over 11 million people were processed through the facility. Following the opening of Ellis Island in 1890, Castle Clinton became the NYC Aquarium. When it closed in 1941, the building survived repeated votes by the NYC Board of Estimate in favor of demolition, and was eventually taken on by the Federal Government in 1950. This photo dates to 1978, and the original One World Trade Center is visible behind the Whitehall Building.

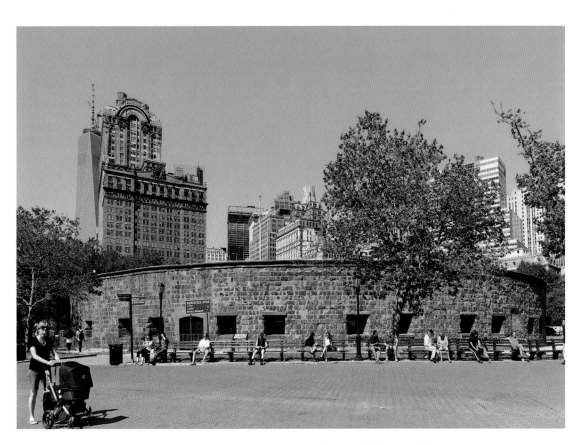

ABOVE: Following a major rehabilitation in the 1970s, Castle Clinton reopened in 1975, and is currently administered by the National Park Service. Restored to its original appearance, it now serves as an administrative unit and departure point for visitors to the Statue of Liberty and Ellis Island, and also contains a small history exhibit. Now over two centuries old, Castle Clinton has witnessed the structural evolution of Lower Manhattan's architecture, including the destruction of the Twin Towers and reconstruction of One World Trade Center, also visible here.

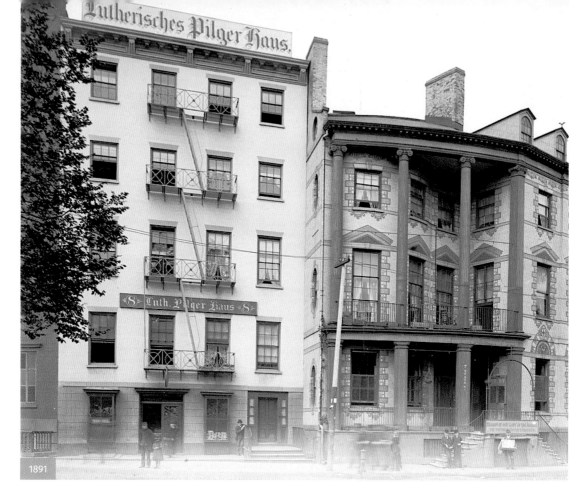

1891

JAMES WATSON HOUSE, STATE STREET
A house often visited by Alexander Hamilton, legal advisor to James Watson

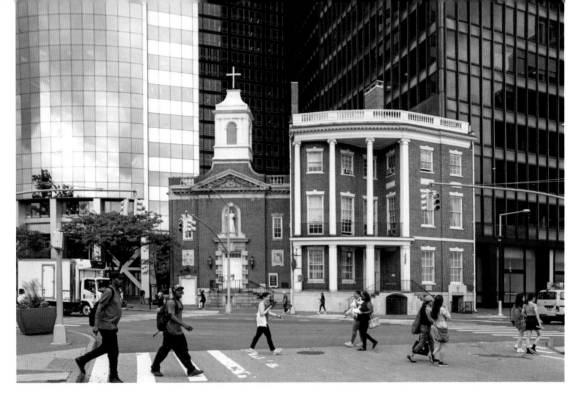

LEFT: James Watson, first Speaker of the New York State Assembly, originally owned the curved mansion (at right). Built in 1793, it was extended in 1806 to incorporate the residence next to it, which sat significantly back from the street. To create a unified façade, a colonnaded portico was added. Following the mass Irish immigration of the late nineteenth century, the Mission of Our Lady Rosary for the Protection of Irish Immigrant Girls opened in 1884. In 1885 the Watson House was purchased to serve as a way station for these immigrant women. The residence on the left, 8 State Street, served a similar purpose, as a Lutheran Pilgrims Home.

ABOVE: By the early 1960s, both buildings had fallen into disrepair and 8 State Street was torn down and replaced by the Georgian/Colonial Revival-style Church of Our Lady of the Rosary, while the Watson house was gutted and transformed into the rectory of the church. Together, they are part of the Shrine of St. Elizabeth Ann Bayley Seton, who lived at 8 State Street in the early 1800s. Seton was the first native-born American citizen to be canonized by the Roman Catholic Church. Once part of a row of eighteenth-century mansions from a time when merchants lived in close proximity to the harbor, the buildings are now dwarfed by towering hi-rises.

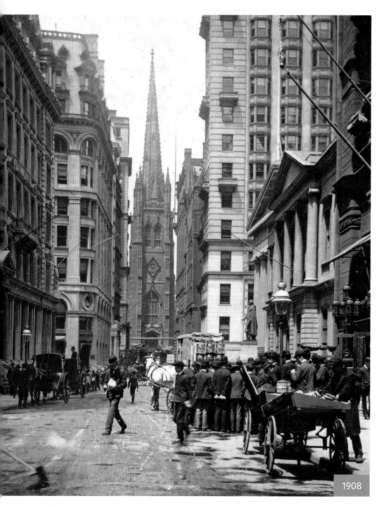

1908

WALL STREET
Synonymous with American finance

LEFT: An eight-block-long street running from Broadway to South Street, the name Wall Street is derived from an earthen wall built by Dutch settlers in 1653; it has now become synonymous with the Financial District and a metonym for the U.S. financial markets. Stock traders began doing business on Wall Street as early as 1790, but the New York Stock Exchange (NYSE) was not formed until 1817, and the organization moved ten times before establishing its first base of operations at the intersection of Broad and Wall Street. This photo, taken in 1908, looks northwest, with the steps of Federal Hall on the right and Trinity Church at the head of the street. The third (and final) Trinity building at this site on Lower Broadway, was completed in 1846. Its spire was the tallest structure on the city skyline.

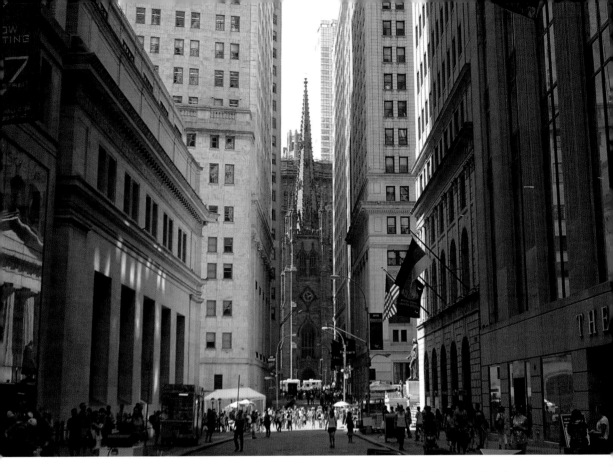

ABOVE: Though Trinity's spire has long since been surpassed in height, its distinctive Gothic Revival architecture stands out amid the glass and steel skyscrapers of Lower Manhattan. The NYSE building was designated a national historic landmark in 1978. The Exchange is visible to the left of the church and though its classical façade and pediment face towards Broad Street, an entrance in the annex gives the building its 11 Wall Street address. The street has more recently gone through another period of change as luxury condos began to mix with historic banking offices.

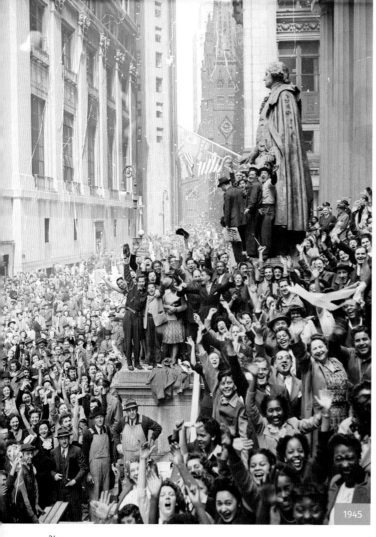

1945

FEDERAL HALL

A place where national history has been made

LEFT: The George Washington statue on the steps of Federal Hall, erected in 1883 by sculptor John Quincy Adams Ward, commemorates the spot where Washington took the oath of office as the first U.S. president in 1789. The building now celebrated as Federal Hall, seen in this 1945 photo, was not, however, the historic building that witnessed the birth of the American Revolution. The original building, erected in 1700 as the seat of the British Colonial government, became the meeting place for the Stamp Act Congress in 1765, which proclaimed "No taxation without representation." Having served as the convening place of the Congress of the Confederation, it became the nation's first seat of government under the constitution in 1789. After the United States capital was moved to Philadelphia in 1790, Federal Hall housed the New York City government, until it was razed in 1812. It was replaced in 1842 by this Greek Revival building, modeled on the Parthenon, and served as the first U.S. Custom House and a branch of the federal treasury before becoming a National Memorial in 1955. In the photo crowds gather to celebrate another key national moment, Victory in Europe, VE Day, May 8, 1945.

RIGHT: Though Federal Hall survived the Wall Street bombing of 1920 that killed nearly 40, it fared worse during the terrorist attacks of 2001. The collapse of the nearby World Trade Centers undermined the historic building's foundations, causing its closure from 2004 to 2006. On September 6, 2002, approximately 300 members of the United States Congress convened in Federal Hall as a symbolic show of support for the city, which was still recovering from the attacks. It was the first meeting by Congress held in New York since 1790. Like several sites in New York, the National Park Service operates Federal Hall as a national monument. Open to the public on weekdays, its exhibit galleries include the Bible used by Washington in his presidential inauguration.

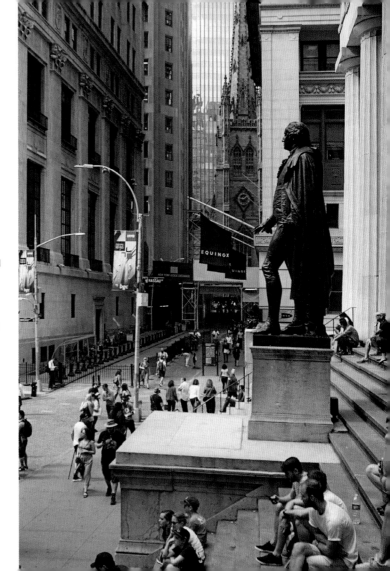

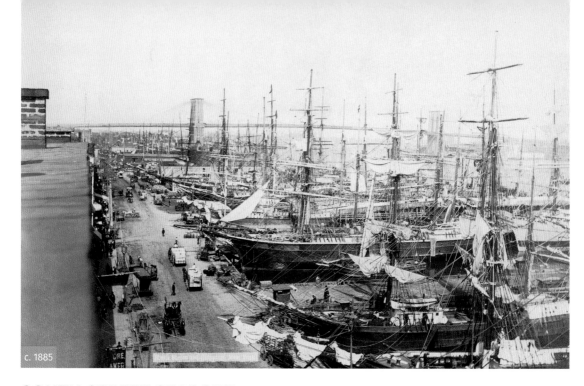

c. 1885

SOUTH STREET SEAPORT

Bustling with trade in the nineteenth century

ABOVE: From the eighteenth century until the post-Civil War replacement of sail by steam, South Street Seaport played a significant role in the growth and development of New York City. The first pier in the area was built in 1625 when the Dutch West India Company established an outpost, and they began to use landfill to extend the coast past the original shoreline at Pearl Street. The influx of settlers led to the quick development of the eleven-block historic district,

Manhattan's oldest neighborhood. Pictured here circa 1885 with the newly completed Brooklyn Bridge in the background, the East River was a "Street of Ships," with piers lining the Manhattan and Brooklyn shorelines. The advent of the ocean liner crossing the Atlantic on regular, fixed schedules, and the use of clipper ships—lighter, faster ships that could carry larger amounts of cargo—further contributed to the Seaport's importance as the busiest port in America.

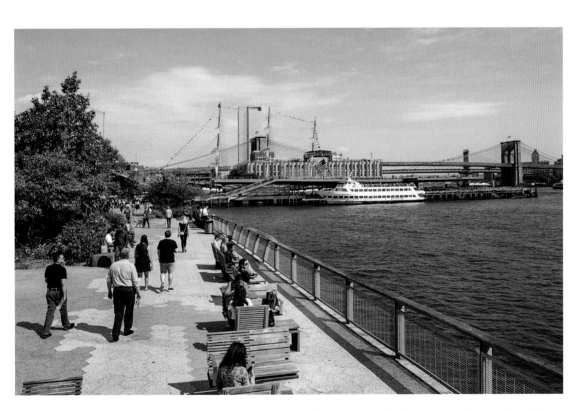

ABOVE: By the mid-twentieth century, however, New York's shipping business had gradually relocated to the Hudson River, and cargo ships docked mainly on ports on the West Side. During the 1950s many of the old Ward Line docks were part-used or vacant. It was not until the 1960s that redevelopment began, and in 1967 the South Street Seaport Museum was founded by Peter and Norma Stanford. Preservation efforts led to Schermerhorn Row, used in the early 1800s as counting houses, being designated an NYC landmark in 1968, and by the 1980s the site had become a shopping center and tourist attraction, with a new glass shopping pavilion on Pier 17. The Seaport was heavily damaged by Hurricane Sandy in 2012, and tidal floods of up to seven feet caused extensive damage. In 2018 Pier 17 was torn down and a new pier opened as part of a broader redevelopment of the neighborhood.

BROOKLYN BRIDGE
Brooklynites were suspicious about the safety of Roebling's pioneering bridge

BELOW: Built to ease the commute from Brooklyn to Manhattan, the Brooklyn Bridge—originally the New York and Brooklyn Bridge—was conceived by Prussian-born engineer John Augustus Roebling in the 1850s. Roebling, killed by tetanus from an injury sustained while taking measurements, would never see the completion of the bridge, and the baton was passed to his son Washington Roebling. It was the world's first steel-wire suspension bridge and a stampede on its opening in 1883 did nothing to quell the worries of suspicious commuters about its safety. Showman P. T.

Barnum marched 21 elephants across the bridge in May 1884 to demonstrate its sturdiness. For two decades it held the title of longest suspension bridge in the world, with a span of 1,595 feet, until it was surpassed by fellow East River crossing, the Williamsburg Bridge, in 1903. Visible on the Manhattan skyline are the Woolworth Building, and the 60-story One Chase Manhattan Plaza, the first International Style building constructed in Lower Manhattan whose rectilinear shape stood in sharp contrast to the nineteenth-century spires.

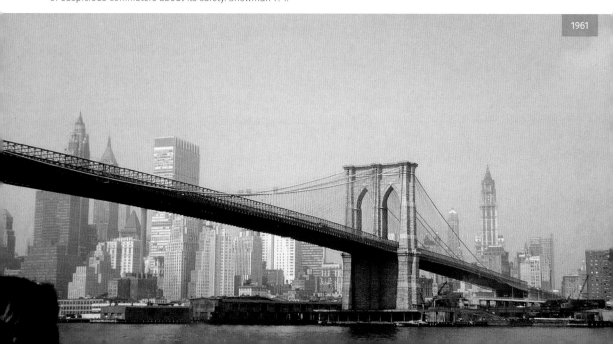

1961

BELOW: At the foot of the Brooklyn Bridge, 8 Spruce Street—originally known as Beekman Tower—completed in 2010, now blocks the view of the Woolworth Building. The Freedom Tower dominates the skyline, but No. 2 World Trade Center, scheduled for completion in 2024, will be the second tallest in the complex. Designed by Bjarke Ingels, it will feature a cantilevering structure with stepped terraces that create the illusion of a leaning tower. Witness to the ever-changing Manhattan skyline for over a century, the Brooklyn Bridge has remained largely the same in appearance since its construction. It was, however, subject to controversy in 2010, when plans to repaint the bridge raised questions over its original color. While old hand-colored lithographs suggested the original color was "Rawlins Red" as a result of the iron-oxide in the paint, historians triumphed with the assertion that it had been a buff color, renamed "Brooklyn Bridge Tan."

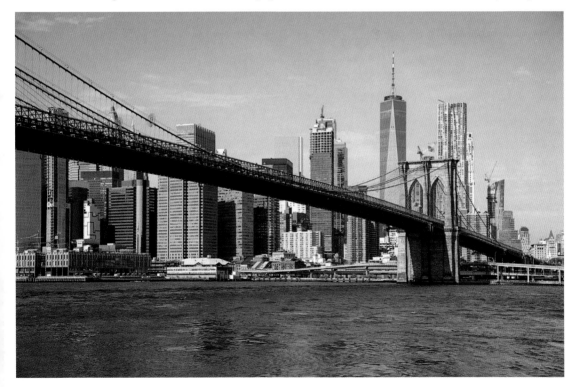

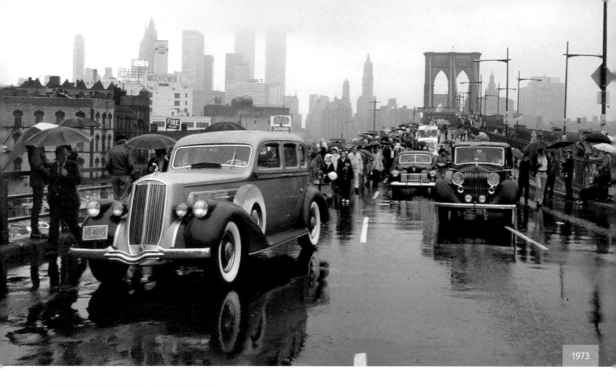

1973

BROOKLYN BRIDGE
Hogs could walk across toll-free from 1891

ABOVE: Though the vintage cars in this photo suggest an earlier date, the Twin Towers just visible on the Manhattan skyline date this photo to 1973, the year of their completion. The bridge has served as an important thoroughfare for both commuters and tourists throughout its history, and the city made a good deal from tolls instituted for carriages and streetcar customers. When the Brooklyn Bridge first opened, it cost a penny to cross by foot, and 5 cents for a horse and rider. Farm animals were charged at 5 cents per cow and 2 cents per sheep or hog. In 1891 the pedestrian toll was dropped and in 1911, a populist policy headed by mayor William Gaynor led to the abolition of tolls on all four East River bridges. In 1948 the Brooklyn Bridge underwent its first major upgrade, and the elevated and trolley tracks were demolished to make way for the widening of each roadway to three lanes.

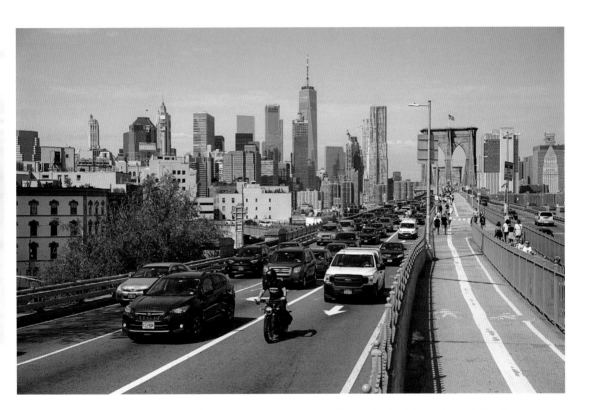

ABOVE: To make the walkway both pedestrian and cycle-friendly, a center line was painted in 1971, creating one of the city's first dedicated bike lanes. As of 2016, it was estimated that 10,000 pedestrians and 3,500 cyclists use the bridge on a typical weekday. Thanks to high traffic volumes, the Brooklyn Bridge has gradually deteriorated over a century due to age and neglect. Prior to World War II, the bridge had 200 full-time dedicated maintenance workers; by the end of the 20th century the number had dropped to only five. The concern was such that in 1974, heavy vehicles including buses, were banned from the bridge, and by 1980 it was in such dire condition that it faced imminent closure. Following the death of a pedestrian in 1981 when two of the diagonal stay cables snapped, a $153 million program of works was commenced in advance of the bridge's 100th anniversary.

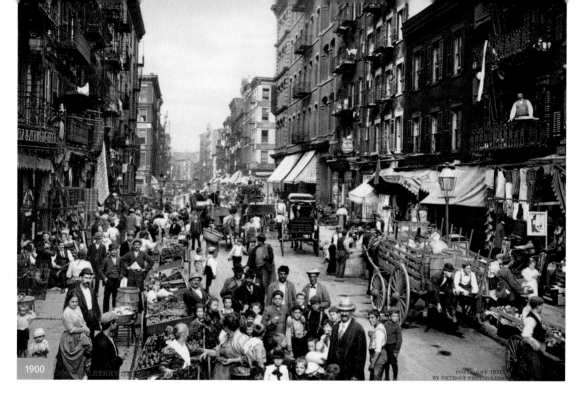

1900

COPYRIGHT 1900
BY DETROIT PHOTOGRAPH...

MULBERRY STREET

Still the heart of Little Italy

ABOVE: This recolored photo, taken by Jacob Riis in 1900, reveals the heart of Little Italy at a time when Manhattan was less a city than a confederation of independent neighborhoods. In the wake of huge waves of immigration from 1899 to 1910, the Italian American enclave on the Lower East Side expanded rapidly. By 1910 half a million Italians lived in New York. In his 1890 book *How the Other*

Half Lives, photographer Riis described the neighborhood's inhabitants, "they are laborers; toilers in all grades of manual work; they are artisans, they are junkmen, and here, too, dwell the rag pickers." The majority lived in overcrowded tenements, and the street served as an important space for the sharing of language, food and customs, as evidenced by the daily outdoor market.

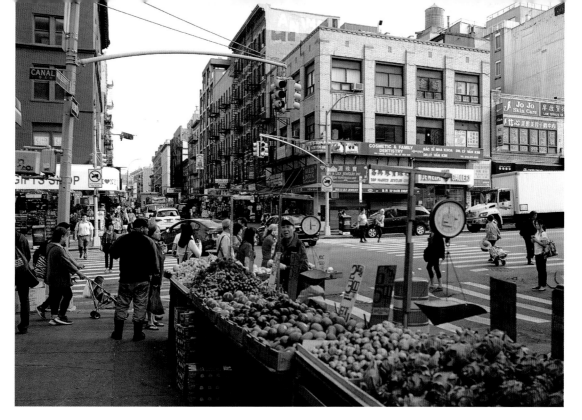

ABOVE: Mulberry Street remains an animated thoroughfare and the central artery of Little Italy. The historic district has shrunk, however, from dozens of blocks to just a few around Mulberry street, as Italians moved out and Chinatown expanded. Despite the neighborhood's many changes over the years, the legacy of the area and its establishments loom large. Restaurant Da Gennaro, formerly Umberto's Clam House, was the venue for the shooting of Brooklyn-born mobster "Crazy Joe" Gallo in 1972, an event depicted in Martin Scorsese's *The Irishman* (2019), and the Mulberry Street Bar was a favorite haunt of Frank Sinatra, receiving its own TV cameo in *The Sopranos* and *Law & Order*. The Silver Screen also brought Mulberry Street to life in 1974 film *The Godfather II*. These days tourists and locals can celebrate Italian culture at the annual September outdoor festival, the Feast of San Gennaro, or visit the Italian American museum at 155 Mulberry Street (due to reopen in 2021).

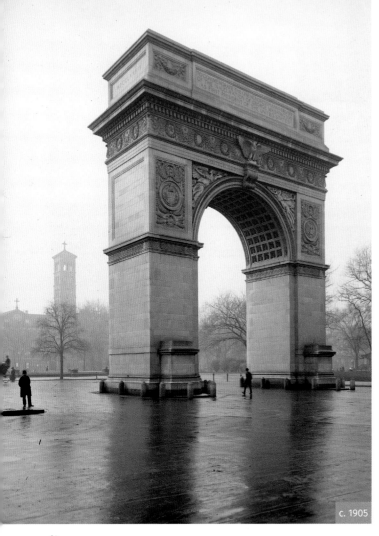

c. 1905

WASHINGTON SQUARE ARCH

Stanford White's arch was so popular they carved it in marble

LEFT: Imitation Roman triumphal arches were constructed globally to commemorate significant events and honor national heroes. Paris had the Arc de Triomphe, London had the Wellington Arch and Washington Square Arch was commissioned in 1889 to celebrate the centennial of George Washington's inauguration as president. One of three temporary arches constructed out of plaster and wood, the monument initially stood over Fifth Avenue, opposite Washington square park, and accompanied two others located by Madison Square Park. It was privately financed by businessman William Stewart, who collected $2,765 from friends to finance it. The Washington Square arch was the best received of the three, and became so popular that when celebrations finished, the false arch was demolished, and a larger permanent stone arch was erected in its place in Washington Square Park (designed by famed Beaux-Arts architect Stanford White). Pictured here circa 1905, the Judson Memorial Church and bell tower are visible in the background, also designed by Stanford White and completed in 1896.

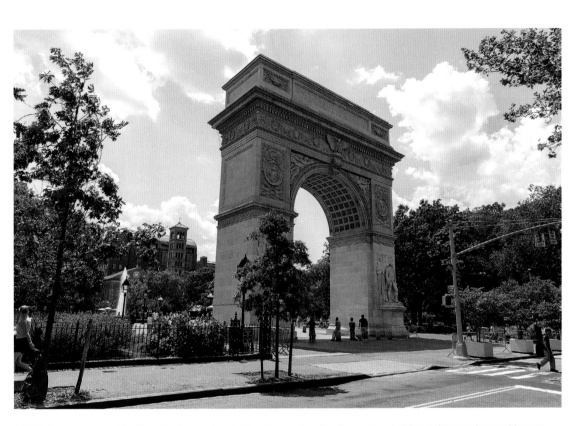

ABOVE: Despite the proliferation of victory arches built at the turn of the century, Washington Square Arch is one of the two remaining monuments. Standing at the center of Washington Square Park, it has witnessed many of the social and cultural movements that redefined the neighborhood throughout the twentieth century. Mark Twain lived nearby on West 10th Street when he returned to New York in 1900. It served as the site of several early labor union marches, and became a haven for the bohemian community and later the Beat generation and "folkies" of the 40s, 50s and 60s who flocked to Greenwich Village. In 1964 the park was closed to traffic and redesigned. The arch is often seen as the unofficial symbol of New York University, as many of the buildings surrounding the park are owned by the institution.

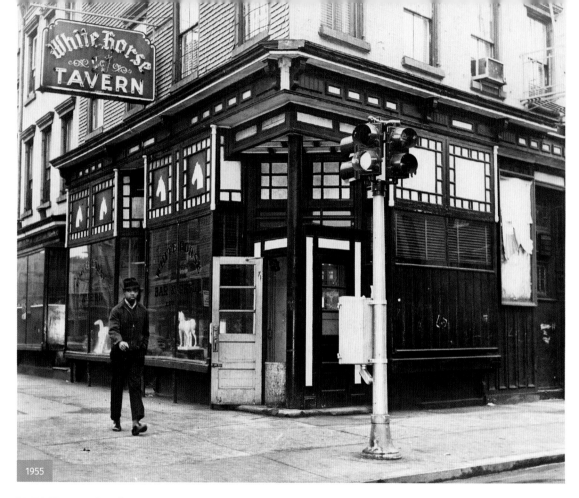

1955

WHITE HORSE TAVERN

Jack Kerouac's regular hang-out and Dylan Thomas's final call

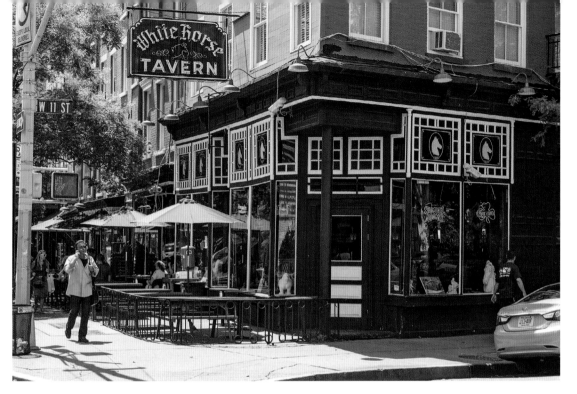

LEFT: The White Horse Tavern first opened in 1880, but it was not until the 1950s that the bar garnered a reputation as a literary and artistic hub of Bohemian culture. Located in Greenwich village, the White Horse Tavern was originally a bar for longshoremen. By the 1930s and 40s, the bar had become a venue for the gathering of left-leaning citizens, and in the 1950s it became popular among writers and artists. Pictured here in 1955, some of its famous patrons included Jack Kerouac, who died at the age of 47 as a result of heavy drinking. He was apparently ejected from the tavern so many times that "Jack Go Home!" was carved into a bathroom stall.

ABOVE: Today, the White Horse Tavern touts itself as the second oldest continuously run tavern in New York City, and the bar makes the most of its numerous famous patrons such as Jim Morrison, James Baldwin, Bob Dylan and the Clancy Brothers. The location of Welsh Poet Dylan Thomas' final drink before his death in 1953, the tavern still serves the last meal he ate there before his death and his portrait hangs above his usual seat. In May 2019 the tavern was sold to restaurateur Eytan Sugarman. Though Sugarman has promised to respect the tavern's historic legacy, regulars still held a rally and an Irish wake for the Horse.

FLAT IRON BUILDING

Critics thought that Daniel Burnham's radical building would cause wind turbulence

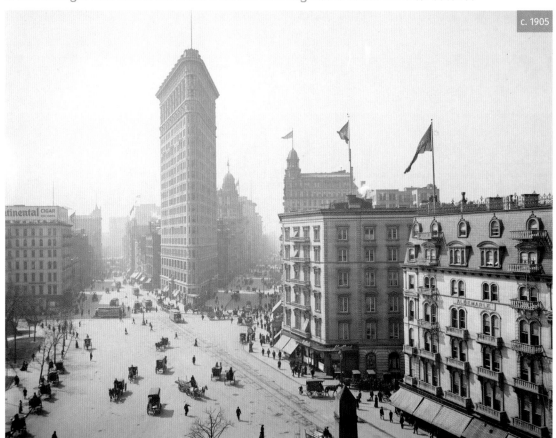

c. 1905

LEFT: Designed by Chicago architect Daniel Burnham, the Flatiron Building gained its distinct name and shape from the wedge-shaped piece of land on which it was built. It was officially named the Fuller Building on its completion in 1902, and was the first tall building to soar north of City Hall. Seen here soon after its completion, the structure's steel skeleton enabled a rapid construction, a story a week. Despite an enthusiastic public response, critics were not positive. They feared the combination of triangular shape and height would create a wind tunnel at the intersection of Broadway and Fifth undermining the structure's stability.

BELOW: "Burnham's Folly" survived the test of time. The Fuller Company vacated the building in 1929, and for decades the area remained relatively undeveloped. The 1990s, however, saw the neighborhood transform into the trendy Flatiron District, with high-end restaurants, shops, and condo apartments converted from office buildings. The Flatiron Building was occupied by Macmillan Publishing between 1959 and 2019. It remains one of New York's most recognizable landmarks, frequently used in films, television shows and commercials. It is employed as the headquarters of the *Daily Bugle* in the *Spider-Man* movies.

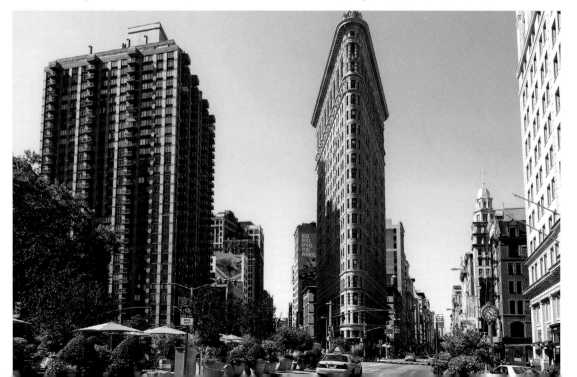

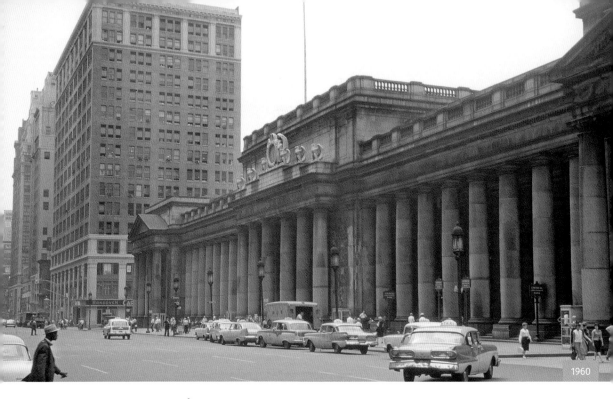

1960

PENN STATION / MADISON SQUARE GARDEN

New York City's greatest architectural loss

ABOVE: Penn Station's two-block-long classical temple, completed in 1910, transformed travel for those arriving in New York. Owned by the Pennsylvania Railroad, travelers before the 1900s had been forced to disembark in Hoboken, New Jersey, and ferry across the Hudson. The invention of new technology enabled the railroad to cut a tunnel under the river in 1904, connecting Manhattan with the rest of the country. Designed by McKim, Mead, and White in the Beaux-Arts style, Penn Station was modeled on the Roman Baths of Caracalla. Vaulted ceilings, towering columns and arched windows adorned the vast space, and the modern station supported eleven platforms serving 21 tracks. By the 1950s, however, passenger traffic had declined, and the Pennsylvania Railroad faced financial trouble.

ABOVE: Faced with a soaring maintenance bill for the old building, the railroad sold the air rights to Madison Square Garden, who planned to construct a new Garden in its place. In exchange, Penn Station moved underground, with a new, air-conditioned smaller station. The new station, however, was suited only to subway services, and not for the busiest railroad station in North America. Despite extensive demonstrations by architects, the city had no power to stop the leveling of a privately owned building, and demolition of the above-ground station house commenced in October 1963. Penn Station is often considered the greatest architectural loss in New York City. Though too late for Penn Station, the city finally acted to protect its architectural heritage and enacted the Landmarks Preservation Law. The new Madison Square Garden opened in 1968 and remains the oldest major sporting facility in the New York metropolitan area, hosting professional ice hockey and basketball, as well as other forms of entertainment.

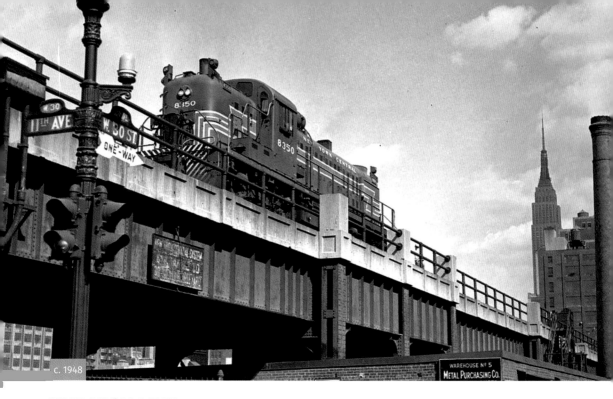

c. 1948

THE HIGH LINE

The freight line that replaced "Death Avenue" is now a major tourist attraction

ABOVE: New York Central built their elevated railroad to supply the freight yards and especially the meatpacking district off 10th and 11th Avenues. Before the line was created 11th Avenue had been dubbed as "Death Avenue." Freight trains ran at street level and despite posting warning horse-riders at the front of trains—known as the West Side Cowboys—and limiting speeds to 6 mph, deaths and injuries continued. The elevated spur was planned in 1925 and started in the 1930s, with the first section opened in 1934. By 1941 the tracks along 10th and 11th Avenues were ripped up, and the Cowboys headed off into the sunset. The photo above shows a diesel locomotive on the short stretch paralleling 30th Street at the junction of 11th Avenue.

RIGHT: Rail freight dwindled in the 1960s and by 1980 the line was disused. The southern elevated section of the West Side Line was demolished, but inspired by the 3-mile-long Promenade Plantée in Paris (opened in 1993), plans were put in place for New York's first elevated urban linear park. The High Line was planted up and opened in stages, starting with the southern section from Gansevoort Street heading north in 2009. The route pressed farther north from West 20th Street in 2011, and then swerved west along West 30th Street (pictured) ending up in the new Hudson Yards in 2014. The 1.45-mile greenaway is now one of New York's most visited tourist attractions. Apart from the attractive planting along the route there are sculptures including Simone Leigh's *Brick House* (bottom right), a 16-foot bronze which stares down 10th Avenue, while the acclaimed *Vessel* can also be seen from the High Line at left in the photo below.

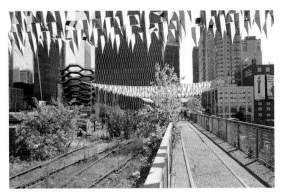

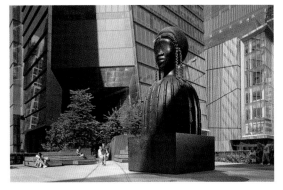

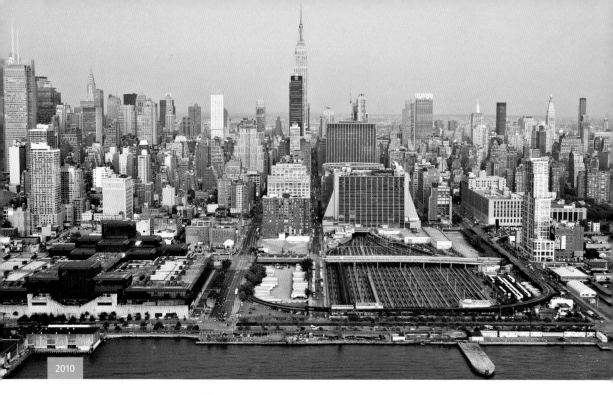

2010

WEST SIDE YARDS/HUDSON YARDS

The biggest building project in the country, anchored by the stylish *Vessel*

ABOVE: The West Side Yards are the last remnants of a vast network of yards and railroads which dominated this stretch of the Hudson waterfront. When the Hudson River Railroad opened in 1851, a yard was built to serve as a depot for trains, and the terminus for steam trains, which were prohibited from traveling any farther south. Extended in the 1860s, the Railroad was purchased by Cornelius Vanderbilt and consolidated into the New York Central Railroad. The yards were used as a freight terminal by Penn Central until the 1970s. When Penn Central went bankrupt, the railyard was acquired by the State of New York. While the northern portion was used to build the Javits Convention Center (visible on the left in this 2010 photo), the southern portion continued to service Penn Station.

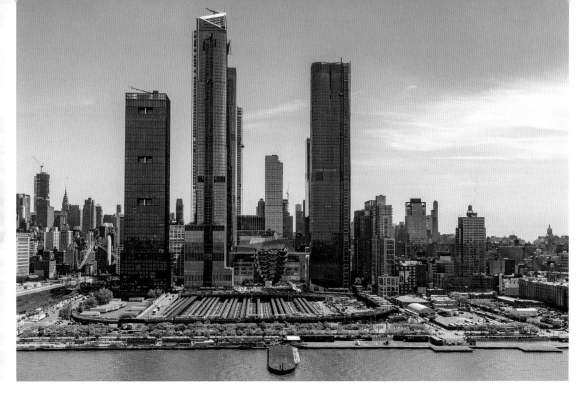

ABOVE: With the value of Manhattan property skyrocketing, a series of proposals have been developed since the 1950s regarding the railyard air rights. These have included a New York Yankees Stadium and a bid for the 2012 Summer Olympics. In 2005 the eastern portion of the yard was re-zoned as part of the Hudson Yards Redevelopment project. Built on a platform above the rail yard, the Hudson Yard project is the most expansive and expensive private development project in the United States, at a staggering cost of $25 billion. The complex features six skyscrapers including the 1,296-foot 30 Hudson Yards, as well as a seven-story luxury mall and an art installation called the *Vessel*, a giant bronze hive of converging staircases. The project has been criticized by architects and urban planners alike, denigrated as a playground for billionaires and a gated community catering to the upper classes. The development has completely altered the skyline of midtown and the project is only half complete. While the western portion of the West Side Yard remains undeveloped, and is therefore visible here, Phase 2 of the Hudson Yard project involves the erection of a second platform and construction of seven more residential blocks.

PIER 86 / USS *INTREPID*
Piers 86 thru 92 on the Hudson handled big ocean-going liners

BELOW: From as early as the 1880s, the Hudson River had begun to replace the historic South Street Seaport as the center of commercial shipping, with the port too shallow for larger, more modern cargo ships. The piers that lined the Hudson River became thriving transport hubs, serving as freight and passenger terminals for transatlantic ships. The S.S. *Leviathan*, seen here at Pier 86 in 1924, was an ocean liner launched in 1913 by the German Hamburg America Line for their transatlantic passenger service. Originally named S.S. *Vaterland*, the ship was seized by the U.S. government during World War I and turned over to the custody of the U.S. Navy. Renamed the *Leviathan* at the suggestion of Woodrow Wilson, she served as a main carrier of troops to France. The ship was decommissioned in 1919, and languished in New York Harbor for three years before reentering commercial service as the flagship of the new United States Line.

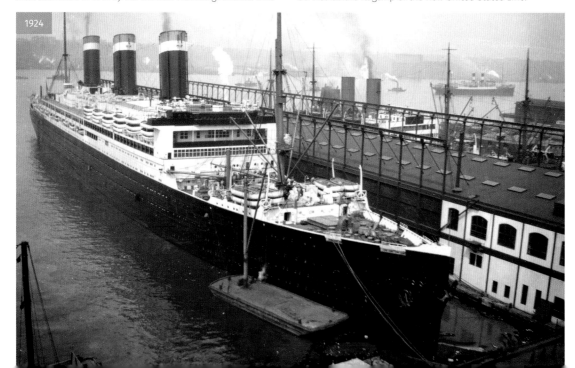

1924

BELOW: Low passenger numbers and high operating costs in the Depression era led to the scrapping of many ocean liners. Though the postwar era was characterized by a flourishing waterfront, the implementation of containerized shipping meant that many longshoremen found themselves out of work by the end of the 1950s. The abandoned piers became a popular gay cruising spot in the 1960s and 70s. In 1982, the Intrepid Museum was founded at Pier 86 with the acquisition of the U.S.S. *Intrepid*, which was saved from scrapping in 1978 and converted into a sea, air and space museum. Commissioned in 1943, the *Intrepid* was built in the latter half of World War II to serve in the Pacific Theater of Operations. The ship was also used during the Vietnam War, and served as the recovery ship for a Mercury and a Gemini space mission. The Intrepid Museum features the Space Shuttle Pavilion, which is home to *Enterprise*, the world's first space shuttle orbiter. Today, Piers 88 and 90 still handle ocean-going ships.

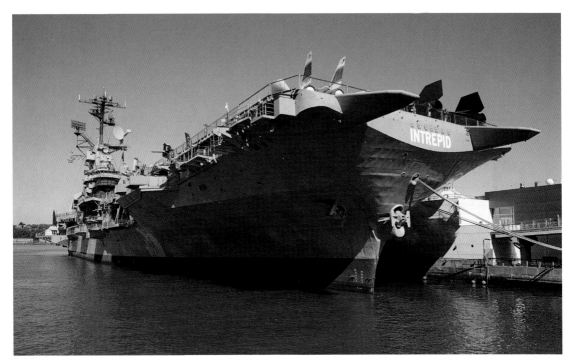

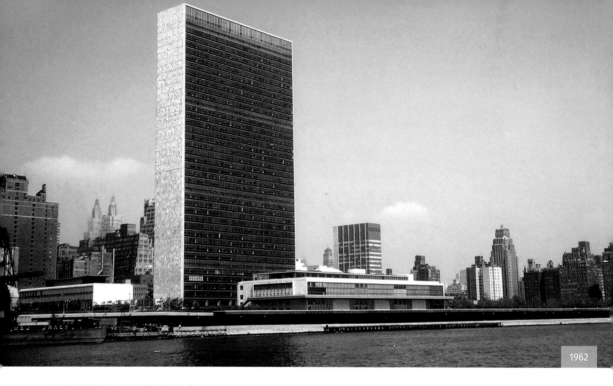

1962

UNITED NATIONS

A city within a city in Turtle Bay

ABOVE: Pictured here in 1962, the United Nations is perhaps the most important intergovernmental organization in the world, and certainly the largest and most internationally represented. The plan for a new world organization was conceived during World War II by the four major allied countries, the U.S., the U.K., the U.S.S.R. and China, and drafted at the White House in 1941. Once the UN Charter was ratified in 1945 following the Allied victory, the United Nations sought to create an independent city that would become a new world capital. Several obstacles prevented this, and subsequently several cities vied for the honor of hosting the headquarters before the East River site was chosen. A 39-story Secretariat building was commissioned and construction started in 1948. The first 450 UN employees moved in before the building was completed in 1952, and in 1953 the headquarters were furnished with the donations of 21 nations.

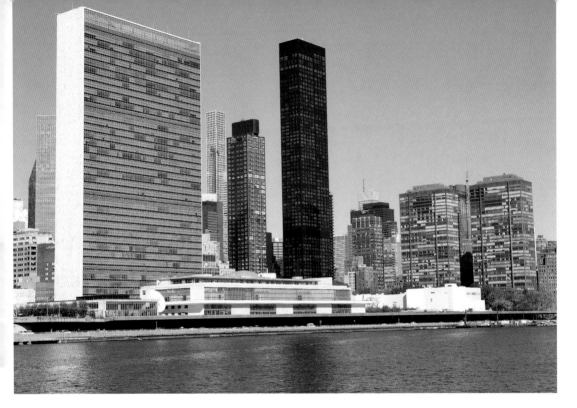

ABOVE: The headquarters hold the seats of many of the principal organs of the UN, including the General Assembly and the Security Council, though none of the organizations' 15 specialized agencies are located here. A concert is traditionally held on UN Day, October 24, as a celebration of the organization's achievements and to commemorate its anniversary as an official entity. The holiday was adopted nationwide in 1948, and internationally in 1971. Remarkably, though the headquarters are situated in New York City, the land the UN occupies is regarded as international territory, and is therefore under sole administration of the UN and exempted from the jurisdiction of local law. The site of the headquarters in the Turtle Bay neighborhood has led to the use of "Turtle Bay" as a collective term for the United Nations as a whole. While the site of the headquarters has remained relatively unchanged since its early construction, several new developments have sprung up in the Turtle Bay area, including the distinct 72-story Trump World Tower seen in this photo, constructed in 2001 with dark, bronze-tinted glass.

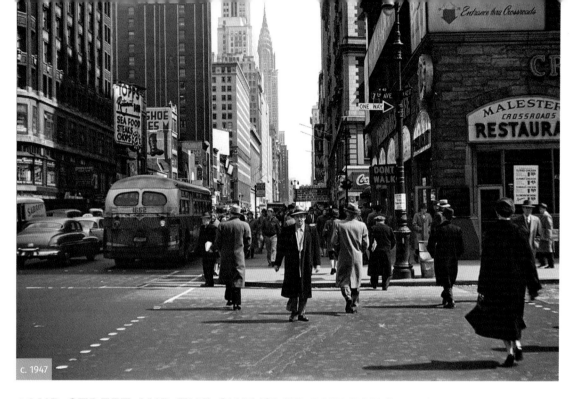

c. 1947

42ND STREET AND THE CHRYSLER BUILDING

New York's most iconic skyscraper raced to be the tallest

ABOVE: In 1947 the landmark Chrysler Building could be viewed down 42nd Street from its junction with Seventh Avenue. Follow the sidewalk down on the right-hand side and you come to the Knickerbocker Hotel, with a Coca-Cola sign fixed to its ground floor corner with Broadway and beyond that, the Bryant Theatre, opened in 1921 as the Cameo Theatre. The Chrysler Building was completed in 1930 at the eastern end of 42nd Street, though its address places it on Lexington Avenue. It was designed by William Van Alen, who was competing with a more conventional skyscraper at 40 Wall Street to become the tallest in New York. The architect concealed its lancelike spire till the last moment and won the contest by 121 feet. The victory was short and sweet; in 1931 the Empire State Building eclipsed them both.

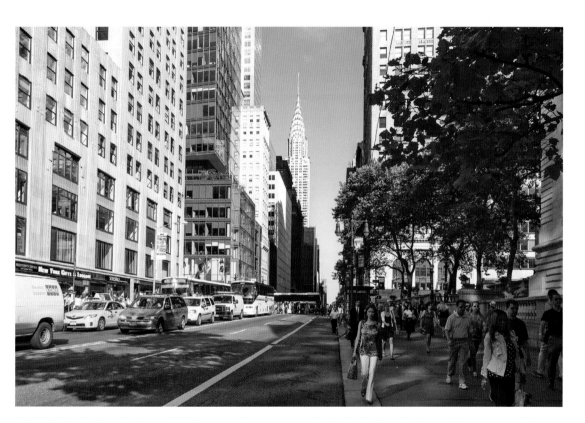

ABOVE: Today, the Chrysler is not visible from 42nd Street and Seventh Avenue. For a sidewalk view of the city's finest skyscraper you need to walk down 42nd Street past Bryant Park and the New York Public Library (at right), as our photographer has done to take this shot. The Chrysler's prestige faded over the decades and by the 1970s it was suffering from a long-term decline in maintenance with cracked walls, leaking windows and hence empty offices. It was sold in a bank foreclosure and in 2002 received a total refurbishment worthy of its iconic status. Back up the street, the Knickerbocker Hotel has escaped the fate of many grand old New York hotels around Times Square —such as the Astor—and become a luxury establishment, something unimaginable in the 1960s and 70s.

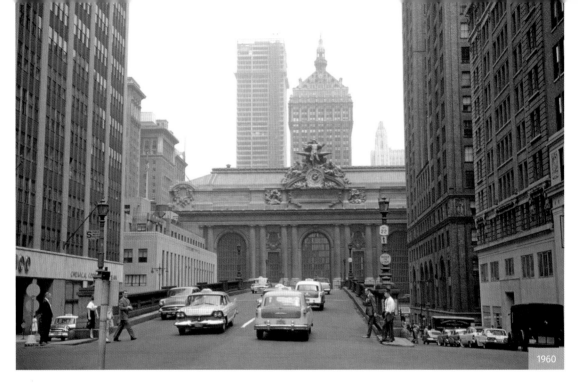

1960

GRAND CENTRAL STATION APPROACH

The lesson of Penn Station had been learned when developers came to call . . .

ABOVE: In the late nineteenth century, railroad magnate Cornelius Vanderbilt merged several railroads to create the New York Central Railroad, with Grand Central Terminal eventually becoming its crowning glory. Completed in 1913, the Beaux-Arts terminal was the third station to stand on the site, with the second reaching maximum capacity at 11.5 million passengers a year by 1897. The triple-arched façade was part of architect Whitney Warren's aim to create a literal and metaphorical gateway to the city. The Helmsley Building, visible directly behind the terminal in this 1960 photo, was completed in 1929 as the New York Central Building and initially intended to be a part of the station complex. It was eventually erected to the north in Terminal City. There the electrification of the Central Railroad and covering of the tracks had enabled the continuation of Park Avenue.

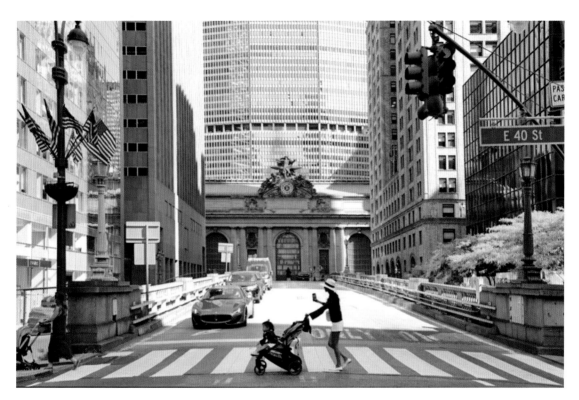

ABOVE: In the intervening years, a number of much taller buildings have surrounded Grand Central Terminal. While buildings along Park Avenue have dwarfed the approach to the station, the 1960s Pan Am Building, now known as the MetLife Building, has bisected the line of sight to the Helmsley Building. The station has fought off financial bankruptcy since the 1950s. Despite numerous plans to redevelop the terminal building—including replacing it with a skyscraper—Grand Central avoided the fate of fellow terminal Penn Station, and was declared a National Historic Landmark in 1976. It has retained the majority of its original features, including the clock adorning The pediment on the southern façade, which contains the world's largest example of Tiffany Glass.

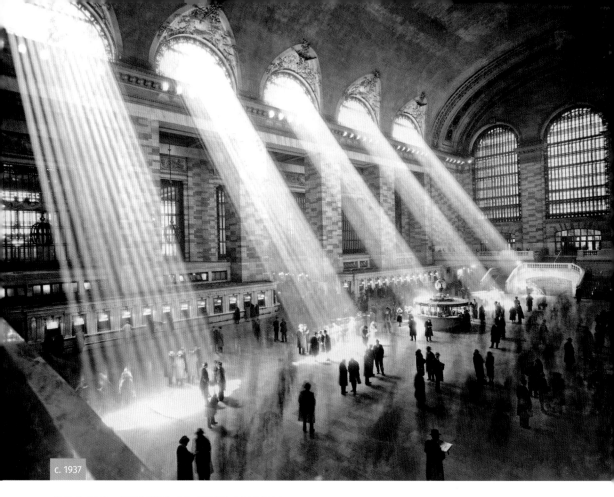

c. 1937

GRAND CENTRAL TERMINAL

A Beaux-Arts cathedral of rail transport

LEFT: Designed as the biggest terminal in the world, both in size and number of platforms, the interior was envisioned as an embodiment of the terminal's monumental character. Striking features included the astronomical cerulean blue mural which covered the ceiling, created by as a many as 50 painters. Illustrating the Mediterranean sky during the October-to-March zodiac, it was mistakenly painted in reverse, forcing officials to justify that it had been painted to represent God's view of the zodiac. Other iconic features included the information booth, the station's perennial meeting place.

ABOVE: As train service declined and the surrounding neighborhood became dilapidated in the 1970s, the interior of the terminal was dominated by billboard advertisements, including a giant screen advertising Kodak that covered the wall of grand windows. Despite the granting of landmark status, it was not until 20 years later that the Kodak screen finally came down, replaced by a marble staircase. The terminal was rocked by the September 11, 1976 attack committed by a group of Croatian nationalists, who planted a bomb in a coin locker, causing one fatality. Today the station is an important transit and retail hub.

BRYANT PARK

A public space since the seventeenth century

BELOW: Designated a public space as far back as 1686 by the colonial governor, what we now call Bryant Park was previously called Reservoir Park after the huge Croton Reservoir next door. In 1853 it was used as the site for the New York Crystal Palace (a replica of London's Crystal Palace), which hosted the Exhibition of the Industry of All Nations in 1853 and shared the fate of its London cousin and burned down in 1858. In 1884 Reservoir Square was renamed Bryant Park in honor of the *New York Evening Post* editor and abolitionist William Cullen Bryant. The reservoir was removed and replaced by the New York Public Library in 1911, which, after one proposal, was going to be built on top of the reservoir. Seen here in 1938 with the Josephine Shaw Lowell Memorial Fountain in the foreground.

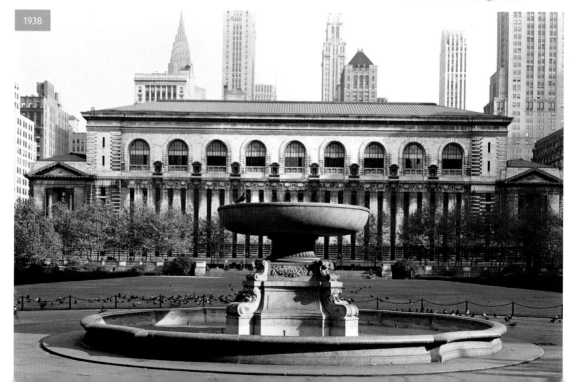

1938

BELOW: Close to 42nd Street and its grindhouse theaters the area around the park was described as "the wild west" in the 1970s and 80s. The park was closed again in 1988 for four years for further restoration work, and after its reopening it started to become the heart of an upscale neighborhood. Today the park is managed by the Bryant Park Corporation (BPC) which organizes private funding for what is a public park. Events here, with the exception of New York Fashion Week, have to be free, and so when the Winter Village arrives with its enormous ice-skating rink, New Yorkers can take to the ice without charge. In 2009 the Josephine Shaw Fountain received an internal heater, and although icicles still gather at its rim, the structure won't freeze solid. The Bryant Park movie nights take place on summer Mondays and there are numerous music concerts throughout the year.

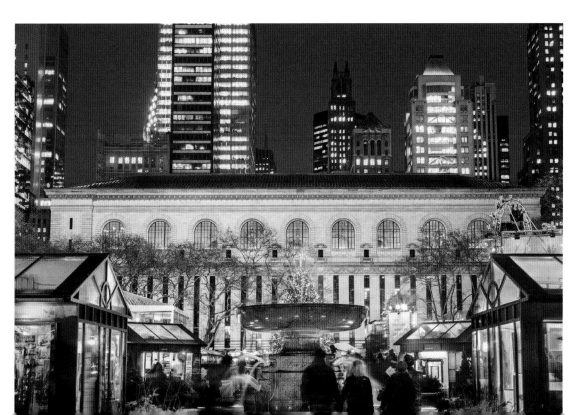

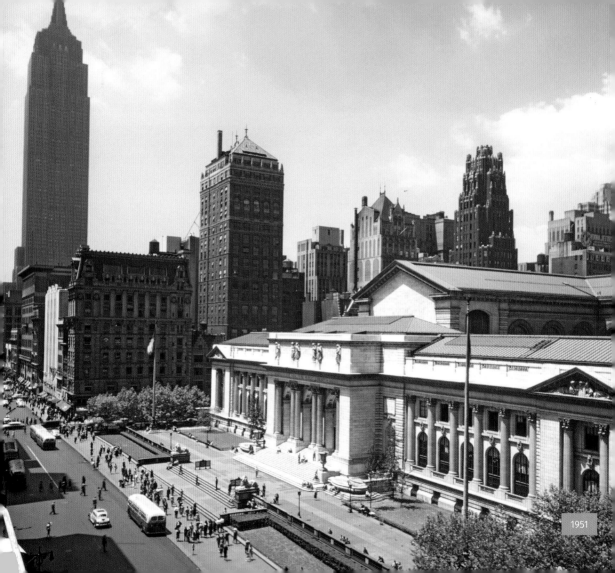
1951

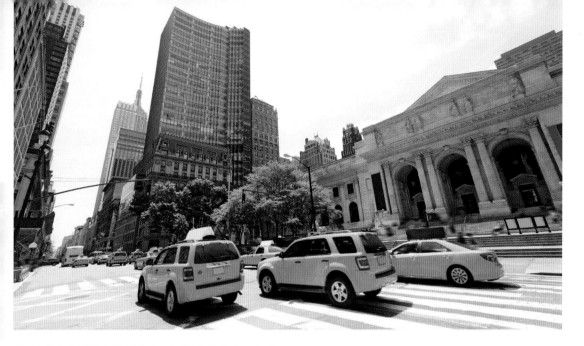

NEW YORK PUBLIC LIBRARY
One of Nikola Tesla's favorite haunts in old age

LEFT: Built on the site of the Croton Reservoir, the New York Public Library (NYPL) was the largest marble structure ever built in the U.S. It was funded by one-time governor Samuel J. Tilden, who left $2.4 million for a public library. Designed with seven floors of stacks and a state-of-the-art rapid delivery system, the 75 miles of shelves housed one million books on its opening in 1910, eight years after construction had begun. Various notable buildings stand on West 40th Street in this 1951 photo, parallel to the library and Bryant Park which lies behind, including 8 West 40th which housed Nikola Tesla's laboratory in 1900.

ABOVE: Upon its opening, the NYPL immediately began to formulate plans for a system of branch libraries throughout the city. Steel baron Andrew Carnegie funded the project, and 39 branches were opened across the boroughs. Today the library has 92 locations, serving 18 million patrons. The 30-story HSBC tower, completed in 1984, now overlooks the New York Public Library. Various buildings in the street are connected to the life of Nikola Tesla, who visited the NYPL frequently in his old age. Tesla received the Edison Medal at the Engineer's Club Building, now Bryant Park Place, in 1917, and also frequented Bryant Park to feed the pigeons.

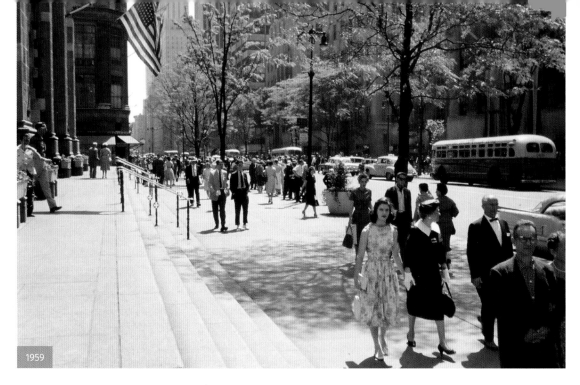

1959

STEPS OF ST. PATRICK'S CATHEDRAL

Fifth Avenue hosts an important religious site, and many places for brand worship

ABOVE: Completed in 1878, St. Patrick's Cathedral became the tallest structure in New York City when its spires were added in 1888. Occupying a whole block of Fifth Avenue it was constructed out of Tuckahoe marble, and could accommodate 3,000 worshipers. Photographed here from the steps of St Patrick's in 1959, the cathedral witnessed the boom and expansion of wealth along Manhattan's Fifth Avenue. From the mansions along Millionaire's Row in the late nineteenth century, the construction of grand apartment houses increased the density of wealthy residents on Fifth Avenue. It was the construction of the first department store in 1906, B. Altman and Company, that set the trend to create a high-end shopping district that attracted fashionable women to upscale stores. Saks Fifth Avenue, pictured just beyond St. Patrick's, was opened in 1924 with a full-block frontage, facing what would become the Rockefeller Center.

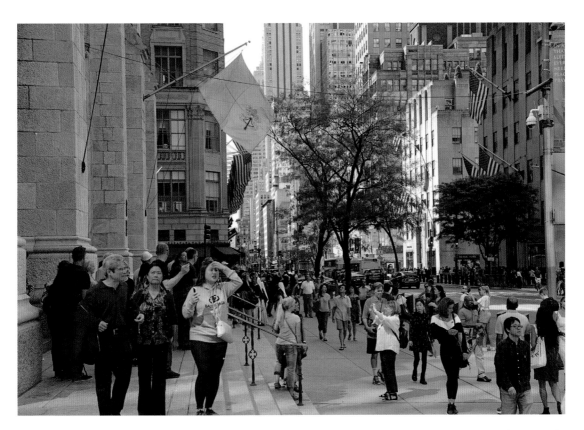

ABOVE: Aside from the clothing and the vehicles, the only marked difference in sixty years is the color of the building façades. Fifth avenue's white marble and limestone became particularly grimy under the strain of decades of atmospheric pollution and have since been sandblasted clean. Unlike many of its rival department stores, such as de Pinna, Bonwit Teller and Wanamaker's, who closed their doors, Saks continues to thrive. An important restoration of the cathedral took place over two years before Pope Francis's visit in September 2015. One of the most visible symbols of Roman Catholicism in New York City, the yellow-and-white Vatican City flag also hangs at the front.

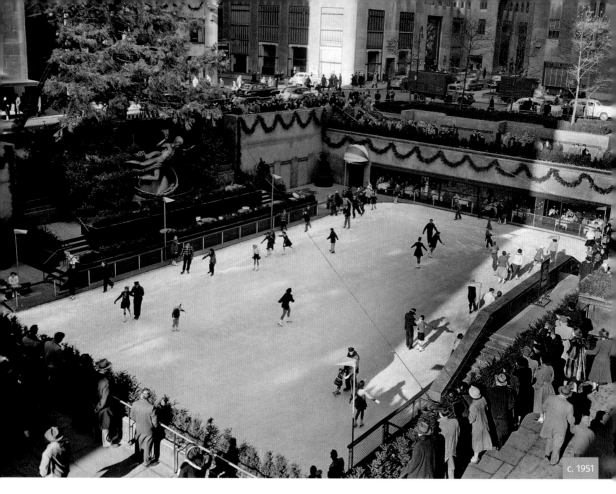

c. 1951

ROCKEFELLER PLAZA ICE RINK

"The world's most famous ice-skating rink"

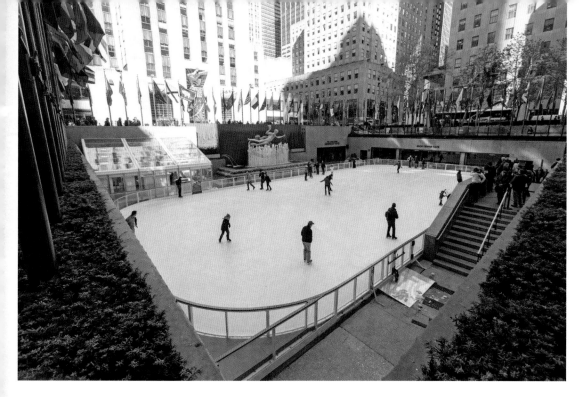

LEFT: The Rockefeller Center was the brainchild of John D. Rockefeller, Jr., who inherited his father's Standard Oil fortune, and Owen Young, the chairman of General Electric. It would house the headquarters of Standard Oil and General Electric and would be the new home of the Metropolitan Opera. The Met's backers took fright at the commercial nature of the venture and passed on the project, giving GE and its radio networks, RCA and NBC, the starring roles. Struggling to attract visitors to their Sunken Plaza, they hit on the idea of turning it into a seasonal ice-skating rink. Starting in 1937, the rink charged 99 cents for admission.

ABOVE: Now billed as "the world's most famous ice-skating rink" (if you ignore the Wollman) today skate hire is $50. More seasonal rinks have appeared across the city with a monster in the Bryant Park Winter Village. The Plaza often appears in movies. Famed for its large Christmas tree, in *Home Alone 2: Lost in New York*, Kevin (Macaulay Culkin) is reunited with his mom here, while in *Elf*, Jovie (Zooey Deschanel) drags Buddy (Will Ferrell) here to take in the giant spruce. The gilded statue is *Prometheus* (1934) by Paul Manship, billed as "the most photographed monumental sculpture in NYC" (that's if you ignore *Liberty Enlightening the World*).

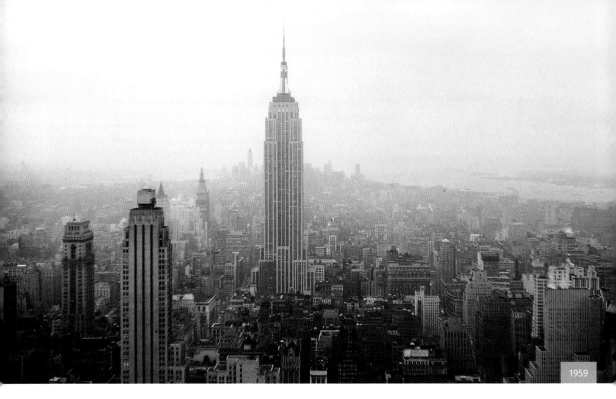

1959

ROCKEFELLER VIEW OF THE EMPIRE STATE

A spectacular view from "The Top of the Rock"

ABOVE: This 1959 view from the seventieth floor of the RCA Building in the Rockefeller Center is little changed from the mid 1930s. Ahead is the Empire State Building (1931), with a mast to anchor dirigibles (a plan that died with the fiery crash of the *Hindenburg* in New Jersey) dwarfing everything else in midtown Manhattan at 1,250 feet to its roof height.

The Rockefeller Center encompasses 19 buildings between Fifth and Sixth avenues and 48th and 51st streets. The Observation Platform of the Art Deco building opened in 1933 on six levels, offering 360-degree views of the city. The top deck was designed to look like a grand ocean liner of its day with deck chairs and ships' air-conditioning vents.

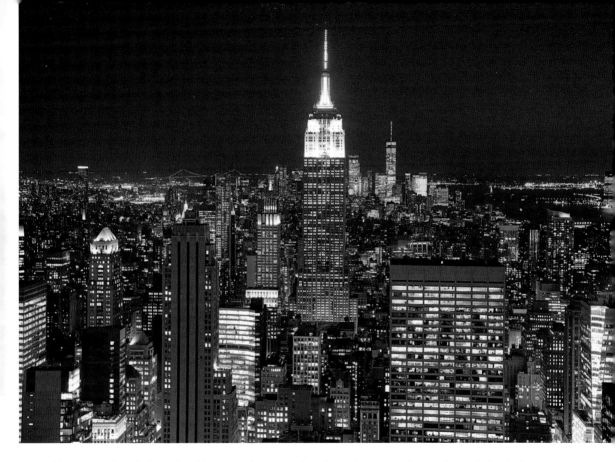

ABOVE: The Observation Platform closed in 1986 and was reopened in 2005 as the attraction, Top of the Rock. It's a spectacular view both night and day; the Empire State Building still dominates Midtown, but beyond it, to the right, is One World Trade Center, the Twin Towers having come and gone in between photos. The 850-foot building has changed names as frequently as a ballpark. From 1933 to 1988 it was known as the RCA Building, from 1988 to 2015 as the GE Building, and from 2015 the Comcast Building. Sometimes this is shortened to 30 Rock. Admission is from 8 am till midnight.

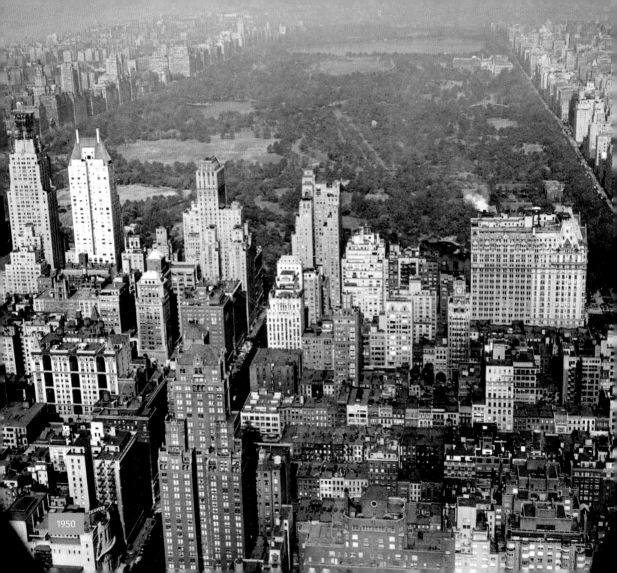

1950

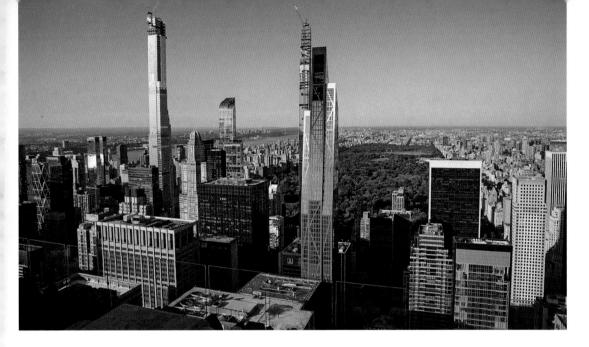

ROCKEFELLER VIEW OF CENTRAL PARK
Offices and luxury condos are interrupting the line of sight

LEFT: Looking north from the RCA Building in 1950 toward Central Park, the elegant Plaza Hotel (to the right of the photo) faces out onto Central Park from its position on 59th Street. It was built in 1907, only 14 years after the first Plaza Hotel, which was considered outdated only 12 years after its opening. On reopening it soon wrested the honors of "most fashionable hotel" of New York from the Waldorf-Astoria. Beyond it, in Central Park, the large mass of buildings to the right of the reservoir is the Metropolitan Museum of Art complex.

ABOVE: Neatly blocking the view of the Plaza Hotel is the ironically named, 50-story Solow Building at 9 West 57th Street. It has been interrupting the line of sight since 1974 and was designed by the architectural firm Skidmore, Owings and Merrill. West 57th has become the new "Billionaire's Row" with condos reaching new heights thanks to the evolution of building techniques. At left is the epic Central Park Tower or Nordstrom Building. Scheduled to top out at 1,550 feet and with ninety-five floors it is due to become the tallest building in the country by roof height, and the tallest residential building.

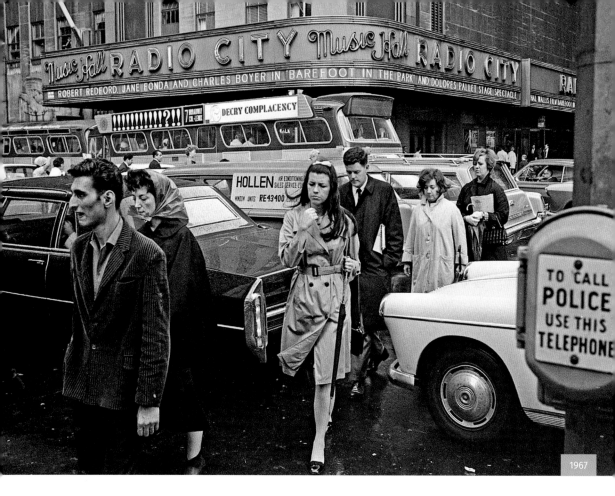

1967

RADIO CITY MUSIC HALL

Filling the cavernous theater proved a problem in the 1960s and 1970s

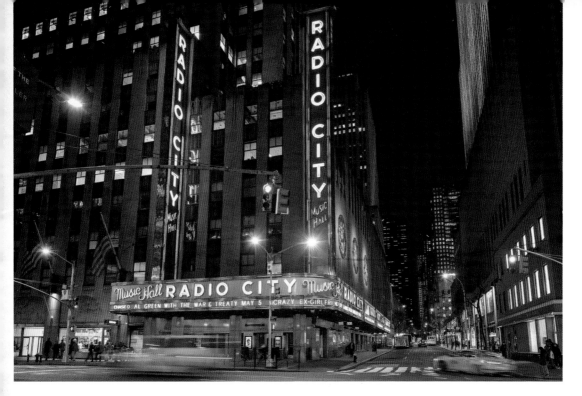

LEFT: This grand music hall opened in midtown Manhattan in 1932. Radio City was the original name for the Rockefeller Center, which was set to host the RCA and NBC radio networks. The music hall was just one building in that Art Deco metropolis. With 6,200 seats, the hall was the largest theater in the world. It began as a vaudeville stage and soon switched to movies, premiering *King Kong* in 1933, in combination with live performances by the dancing Rockettes. It was a top showplace for family entertainment in the 1950s, but fell on hard times in the 1970s.

ABOVE: Things got so bad, at one point the sale of Radio City's air rights was discussed in order to fund redevelopment of the decaying venue. Now beautifully restored, its striking Art Deco interior is once again a premier venue for live concerts. Many events, like the MTV Awards, the Tony Awards, and the Grammy Awards, are televised here, and the NFL Draft was an annual fixture from 2006 to 2014. The Rockettes still perform in a "Christmas Spectacular." During the rest of the year, a diverse cast of performers from Cirque du Soleil to Riverdance to Lady Gaga and Mariah Carey take the stage.

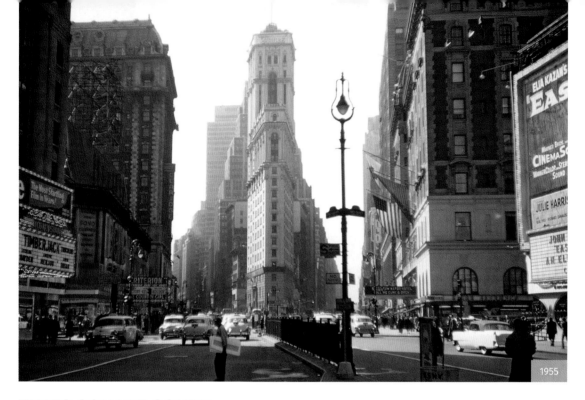

1955

TIMES SQUARE SOUTH

The original Times Building lies deep beneath the adverts and screens and remodeling

ABOVE: In 1904, the *New York Times* ventured far uptown from its longtime home on Newspaper Row to a strikingly different building, the Times Tower. Rising 24 stories and prominently placed on a triangular site at the intersection of Broadway, 42nd Street and Seventh Avenue, the tower's height and unique site made it the focus of the area that soon would be called Times Square. The paper outgrew the tower by 1913 and moved out, but the name remained visible on top, as in this 1955 view. In the 1920s, when Broadway theater marquees and new movie palaces were flashing in Times Square, the tower also began to sport neon signs. In the 1930s and 40s, burlesque and peep shows, penny arcades, and dime-a-dance halls transformed Times Square and the slide downmarket began.

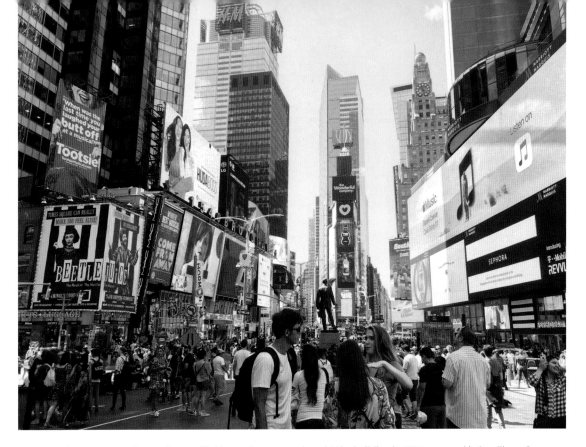

ABOVE: In the 1960s, prostitutes, drug trafficking and adult movies had spread throughout the area, shutting down dozens of legitimate theaters. Purchased by Allied Chemical, the tower gained a concrete and marble sheath, belted by a moving sign of flashing headlines. But the damage had been done, forever turning the proud symbol of Times Square into just another billboard. A new owner bought the building in 1975, renamed it One Times Square, and planned to turn it into a wedge of mirrors. Fortunately, the plan was never carried out, but the building would undergo another disfiguring transformation. Although it is still commonly known as the Times Tower, its original form, covered by advertising screens, is unrecognizable.

TIMES SQUARE LOOKING NORTH

Reclaimed from its low-rent 1970s reputation

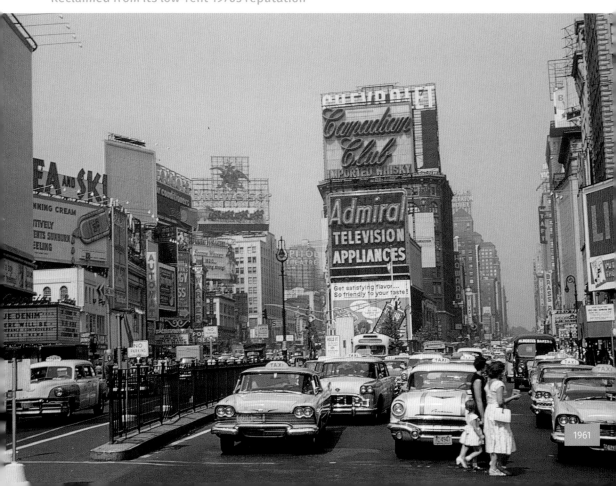

1961

LEFT: Looking north from Times Square in 1961, Broadway strikes off to the left, while Seventh Avenue is filled with multicolored cabs on the right. There is one distinct building visible in both Then and Now photos. The Brill Building at the corner of 49th Street and Broadway is adorned by a large Budweiser sign. This was the office building which housed many record labels and studios, where some of the greatest American songwriting talent worked. Johnny Mercer, Burt Bacharach, Gerry Goffin, Neil Diamond, Neil Sedaka, Carole King, Jerry Leiber and Mike Stoller all worked in the Brill Building.

BELOW: By the late 1960s drug trafficking and pornographic movies had spread through the area, swallowing up or shutting down dozens of Broadway theaters. The survivors retreated to the side streets, but the sleaze followed. The neighborhood finally cast off its squalid past in the 1990s through a major investment of public and private funds that restored theaters and brought in new office towers, hotels, megastores, and family attractions. Cabs in New York are no longer multicolored. In 1967 a law was brought in that all officially licensed cabs had to be painted Dupont M6284 "school bus" yellow.

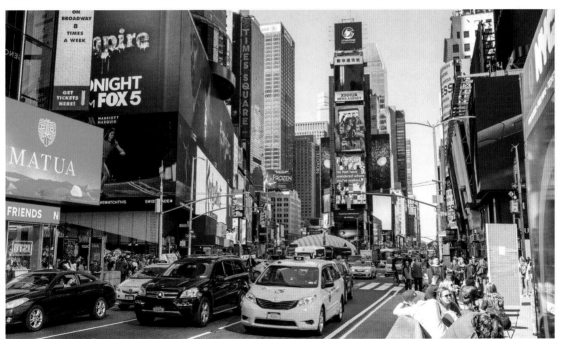

SHUBERT AND MAJESTIC THEATERS

Two cultural landmarks in the theater district

BELOW: Lee Shubert was one of the partners who leased a site between 44th and 45th streets on which they built two theaters, the Booth and the Shubert, both designed in the Venetian Renaissance style. Lee, along with brother Jacob. J. Shubert, ran the larger auditorium and named it the Sam S. Shubert Memorial Theatre after their brother who had died in 1905. It opened in 1913 with a production of *Hamlet*. A little farther down West 44th Street, the Majestic Theatre was originally built in 1927 by real estate magnates, the Chanin Brothers, as part of a three-theater complex of differing sizes. In 1930, the Chanins transferred ownership of all three houses to the Shuberts.

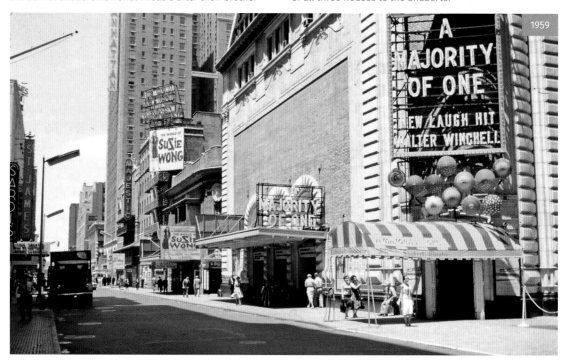

BELOW: Both the Shubert and the Booth, along with the Majestic have survived into the twenty-first century under the stewardship of the Shubert Organization. Other nearby theaters, most notably the Astor, Gaiety, Morosco, Bijou and original Helen Hayes have been razed. The Shubert has seen many theatrical triumphs over the years. The theater's longest tenant was *A Chorus Line*, which ran for 6,137 performances from 1975 to 1990 and set the record for the longest-running show in Broadway history. This record has since been broken by its neighbor, the Majestic, which has been hosting *Phantom of the Opera* since 1988. In between them is the Broadhurst Theatre.

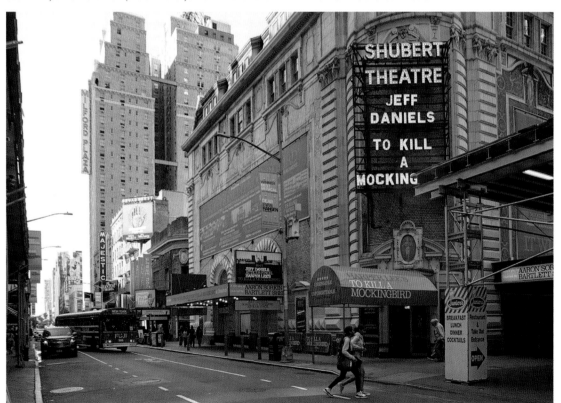

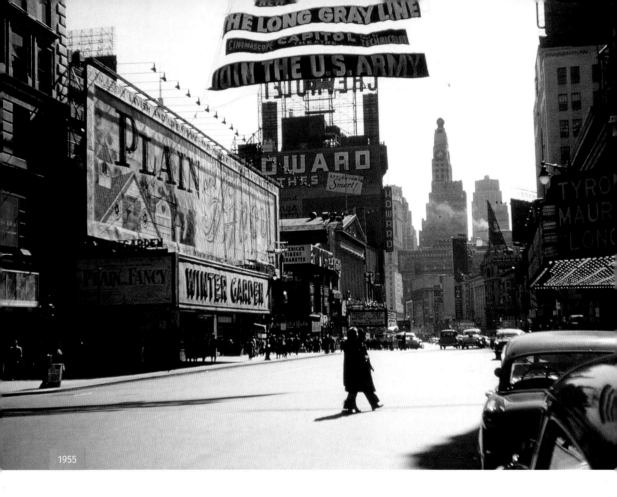

1955

WINTER GARDEN THEATRE

The home of musicals which require complex staging

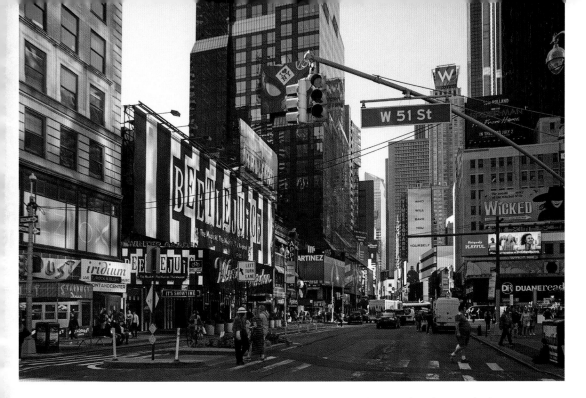

LEFT: The Winter Garden Theatre started life in 1896 as the American Horse Exchange, a project of William Kissam Vanderbilt. The building's purpose was soon redundant. The Shubert brothers leased the building and reconstructed it as a theater, opening in 1911 with Al Jolson starring in *La Belle Paree*. Remodeled in 1922 by Herbert J. Krapp, the stage is unlike other Broadway theaters in that it is wide with a low proscenium arch. In 1955 it was hosting *Plain and Fancy*, a musical comedy about the Amish community which ran for eight months and starred a 12-year-old Scott Walker, soon to find fame with the Walker Brothers.

ABOVE: Over the years the Winter Garden has seen everything from vaudeville to burlesque, to small stints as a movie house, but predominantly it has been used as a theater. The auditorium was transformed for Andrew Lloyd Webber's *Cats*, which opened on October 7, 1982 and ran for 7,485 performances. Most recently it has hosted *Beetlejuice*, an adaptation of Tim Burton's 1988 film and another musical with an elaborate set. Though the show regularly grossed over $1 million a week, the Shubert Organization moved it in favor of Hugh Jackman's revival of *The Music Man*, which is due to take over in fall 2020.

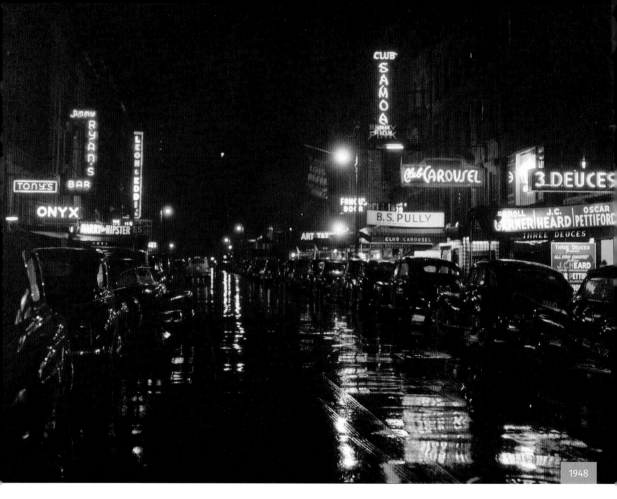

1948

52ND STREET JAZZ CLUBS

These days they're "all gone"

LEFT: After the repeal of Prohibition in 1933, the block of 52nd Street between Fifth and Sixth Avenues became renowned for its jazz clubs such as the Three Deuces, Club Carousel, Famous Door and Jimmy Ryan's. Gilbert J. Pinkus—"The big cigar with the little man"—was doorman at the Three Deuces and also known as "The Mayor of 52nd Street." This photo was taken in 1948 by writer-photographer William P. Gottlieb who was the *Washington Post* jazz correspondent. All the jazz greats played here including Miles Davis, Dizzy Gillespie, Billie Holiday, Thelonious Monk, Charlie Parker, Louis Prima, Art Tatum and Fats Waller.

ABOVE: By the late 1940s the jazz scene was moving elsewhere. In 1943, Club Samoa had changed from a jazz club to a strip club and in 1949 the Onyx followed suit. Most of the jazz clubs on 52nd Street either closed their doors or moved to new locations. Jimmy Ryan's lasted until 1962 and then moved to a venue on West 54th Street, finally closing in 1983. Gilbert J. Pinkus moved to become doorman at Jimmy Ryan's and was still working there in 1980 when he was tragically killed by a truck on his way to work. Like much of the theater district, the buildings left behind were razed and became part of the relentless urban renewal.

CARNEGIE HALL
A music venue with celebrated acoustics

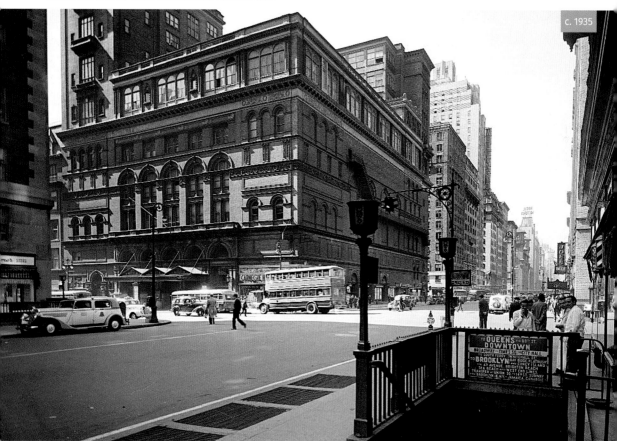

c. 1935

LEFT: Scottish steel magnate Andrew Carnegie was better known for his funding of libraries than the arts but he paid a million dollars to create New York's premier music venue. The magnificent Neo-Renaissance building known for its marvelous acoustics at 57th Street and Seventh Avenue opened in 1891. In its opening year, the Polish pianist Ignacy Jan Paderewski made his American debut at the hall. The success of Carnegie Hall spelled the end of music concerts at Steinway Hall (East 14th Street) and Chickering Hall, run by their respective piano companies. Carnegie Hall moved the fashionable music scene north to 57th Street.

BELOW: Steinway Hall relocated to 57th Street in 1925, but the New York Chickering Hall was demolished in 1902. After 70 years Carnegie Hall itself came under threat. Once home to the New York Philharmonic, it was scheduled for demolition in the 1960s when the orchestra moved to the Lincoln Center. A coalition of musicians, politicians and civic figures led by violinist Isaac Stern saved Carnegie Hall. It became a listed landmark in 1964 and was restored to its original glory in the 1980s. Carnegie Hall Tower, a 60-story building constructed next door, provides the revenue to keep the music playing in the historic hall.

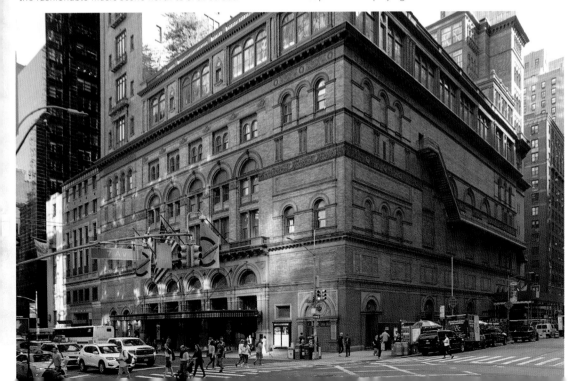

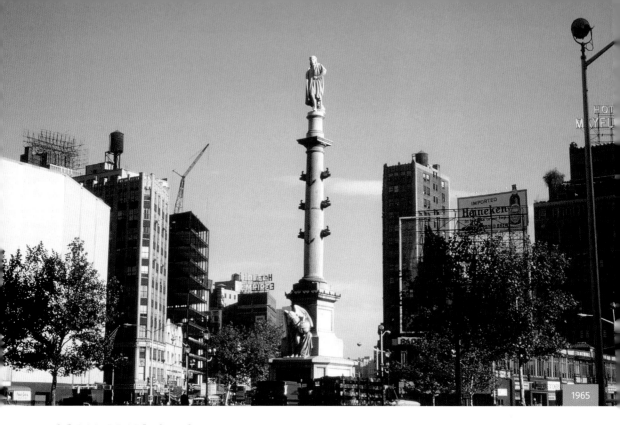

1965

COLUMBUS CIRCLE

Italian-Americans were keen to celebrate the Italian who discovered the New World

ABOVE: This busy intersection of West 59th Street, Broadway and Central Park West became known as Columbus Circle on October 12, 1892. On that date, the 400th anniversary of Columbus's landing in the New World, Italian Americans dedicated the marble column in the center of the circle. Two years later, they topped it off with the statue of Columbus. The low structure beyond Columbus, to the right, was formerly an equestrian school, which was succeeded by an automobile showroom.

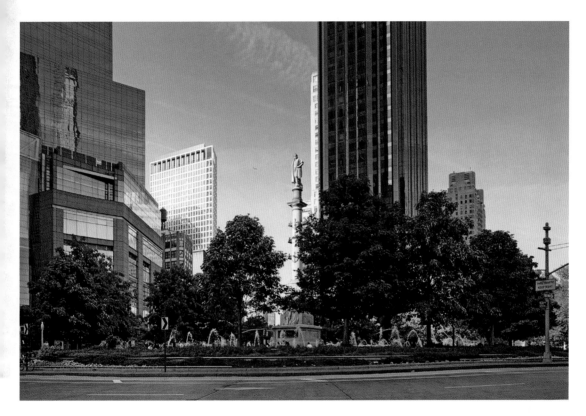

ABOVE: The tower at the apex of Broadway and Central Park West went up in 1970 as the Gulf and Western Building. In 1996, it became the Trump International Hotel and Tower. On the left is the base of the Time Warner Center, a shopping, hotel, and entertainment complex built in 2003. No longer the cheap side of the park, Central Park West now rivals Fifth Avenue for high-priced living. In front of the Trump Hotel is a model of the *Unisphere* sculpture erected in Flushing-Meadows Park in Queens for the 1964 World's Fair. Donald Trump, a native of Queens, liked the *Unisphere* so much that he commissioned this smaller version to stand in front of his hotel.

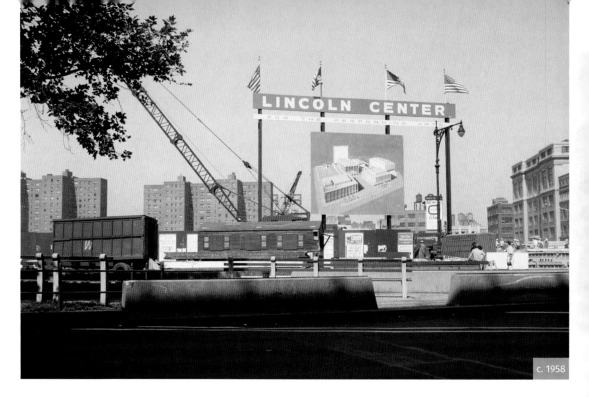

c. 1958

LINCOLN CENTER

New York's trinity of high culture

ABOVE: The Lincoln Square neighborhood was chosen for a large-scale urban renewal project. John D. Rockefeller raised half the $184 million funds and city planner Robert Moses was instrumental in pushing the project forward. Different architects were hired to build the three major auditoriums; the Philharmonic Hall, the New York State Theater and the Metropolitan Opera House, which were opened in 1962, 1964 and 1966 respectively. Like a modern-day Roman Forum, the collection of classically inspired buildings, all clad in travertine marble, would face into a public plaza. It covered 16 acres of Manhattan's Upper West Side and, apart from the large venues, was scheduled to house a dozen arts institutions and organizations involved in every type of musical and theatrical performance.

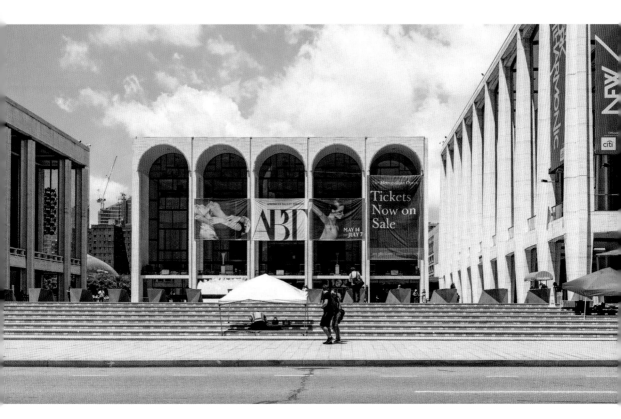

ABOVE: The focal point is the Metropolitan Opera House (center) whose Austrian crystal chandeliers shine through the monumentally arched windows. One of the more successful products of the urban renewal projects of the 1960s, the Lincoln Center complex is the work of leading architects of the day, including Philip Johnson who designed the New York State Theater on the left. Johnson also designed the plaza, inlaid with spokes of marble encircling an illuminated fountain. It was renovated in 2009 and now performs an even more spectacular water ballet, shooting sprays as high as 40 feet with 475 gallons of water in the air. The long flight of steps leading to the plaza was also rebuilt to provide easier access from the street. The plaza was part of a $1.2 billion renovation project.

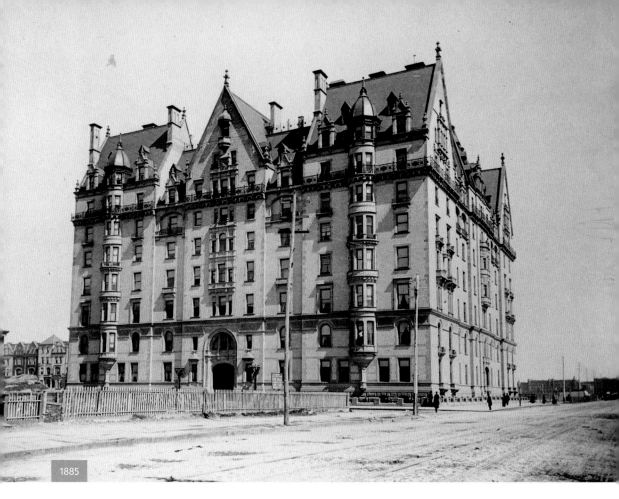

1885

DAKOTA BUILDING
Lennon and McCartney had their last meeting here

86

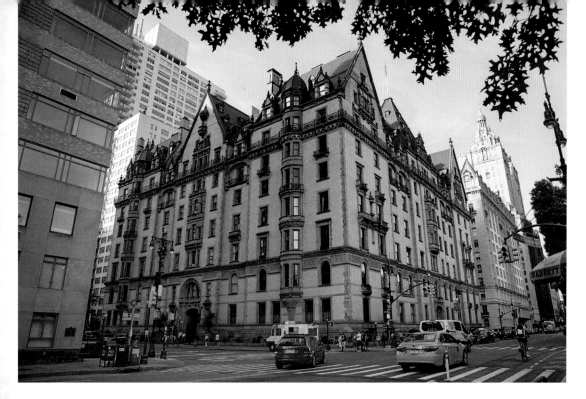

LEFT: Constructed between 1880 and 1884, the Dakota Apartments were commissioned by the head of the Singer Manufacturing Company, Edward Cabot Clark. Although the apartments had fine park views, at the time, West 72nd Street was a long way away from fashionable society in Midtown Manhattan. No two rooms were alike and they varied in size from four rooms to 20. It was elegantly appointed, with a *porte-cochere* entrance, allowing carriages inside for passengers to disembark under cover. There were also private gardens, croquet lawns, and a tennis court, along with a multistory stable building.

ABOVE: Today, The Dakota is run as a co-op and the board of directors can block the sale of apartments to residents they dislike. There is a history of creative people living in the building, including Leonard Bernstein, Judy Garland and Rudolf Nureyev. John Lennon and Yoko Ono moved here in 1973. It was in The Dakota, in April 1976, that Paul McCartney and John Lennon had their last meeting—when they briefly considered cabbing it down to *Saturday Night Live*, taped at the Rockefeller Center, as a joke to tell Lorne Michaels the Beatles were reforming. In 1980 Lennon was gunned down outside, having just signed an autograph for Mark Chapman.

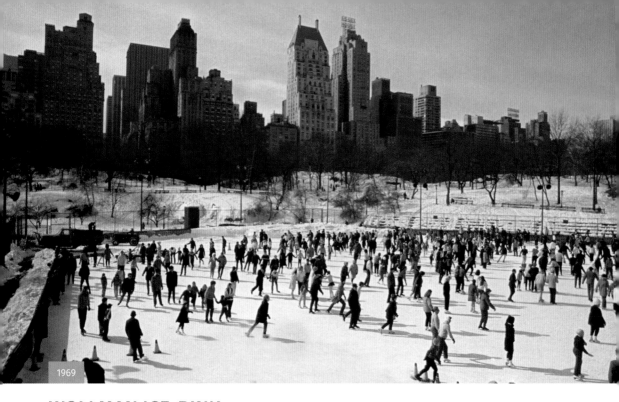

1969

WOLLMAN ICE-RINK
The tradition of skating in Central Park dates back to 1858

ABOVE: As soon as the Central Park lake was carved out of a swamp and flooded in the park's first winter in 1858, people by the thousands rushed in to enjoy what newspapers called "the skating mania." On an average winter day in the 1860s, thirty thousand people came to skate or watch the skaters. Skating on local ponds had been a popular activity for many years, but many were swallowed by the expanding city. Since the 1950s, several generations of New Yorkers have grown up without ever knowing that the lake was once a place for skating. In 1945 an artificial rink was proposed and Kansas-born Kate Wollman, daughter of a wealthy stockbroker, contributed the funds to build it. The Wollman Rink opened in January 1951 on a 2-acre site north of the pond.

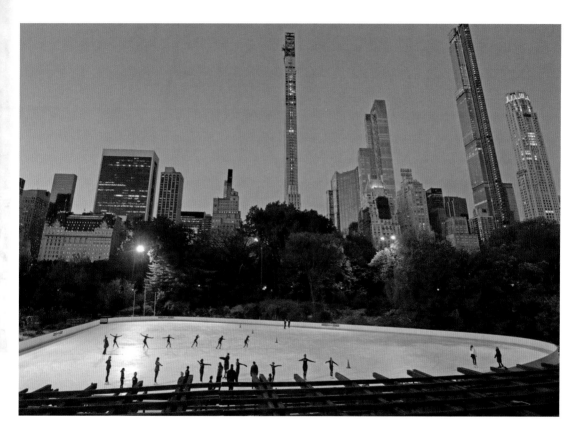

ABOVE: After it was opened the rink drew criticism for interrupting picturesque views of the park. Nonetheless it has become nearly as popular as the lake and a fixed feature of Central Park. Measuring 214 by 175 feet, Central Park's Wollman Rink was the world's largest rink in its day. Closed in 1980 after the concrete floor started to break up, it didn't reopen again until 1987. Donald Trump's organization struck a deal to make the final repairs in return for the rink concession and that of a nearby restaurant. Today, as many as 4,000 ice-skaters use the rink on a daily basis. A children's amusement park takes over the rink in the summer season, and the arena has also been used for polo events.

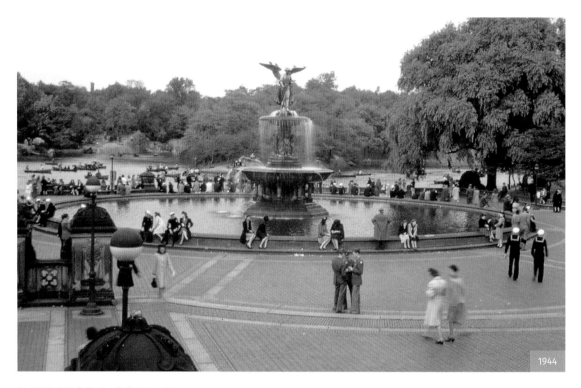

1944

BETHESDA FOUNTAIN

Topped by an angel, the inspiration for an award-winning play

ABOVE: Central Park's Bethesda Fountain overlooking the park lake is one of the most scenic views found in the middle of a great American city. The fountain is topped by the winged *Angel of the Waters*, which celebrates the clean water first brought to the city by the opening of the Croton Aqueduct in 1842. Sculptor Emma Stebbins was inspired by a Biblical passage describing an angel who bestowed healing powers on the pool of Bethesda in Jerusalem. In this wartime view a great number of service personnel are making use of their leave in Central Park.

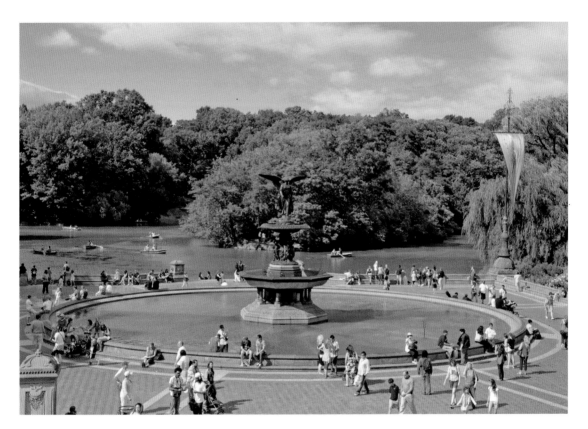

ABOVE: In the 1960s, the fountain became a hippie hangout, at times called "Freak Fountain." Physical abuse, made worse by continued neglect during the city's fiscal crisis of the 1970s, left the terrace scarred with graffiti, gouged carvings, and broken stairs. In the 1980s, the newly formed Central Park Conservancy raised funds to conduct a four-year restoration program, the beginning of a highly successful campaign to repair the entire park. Today, Bethesda Fountain, like the rest of Central Park, has been returned to its pristine glory. The statue of the angel, the most photographed monument in the park, was the inspiration for Tony Kushner's award winning play, *Angels in America*.

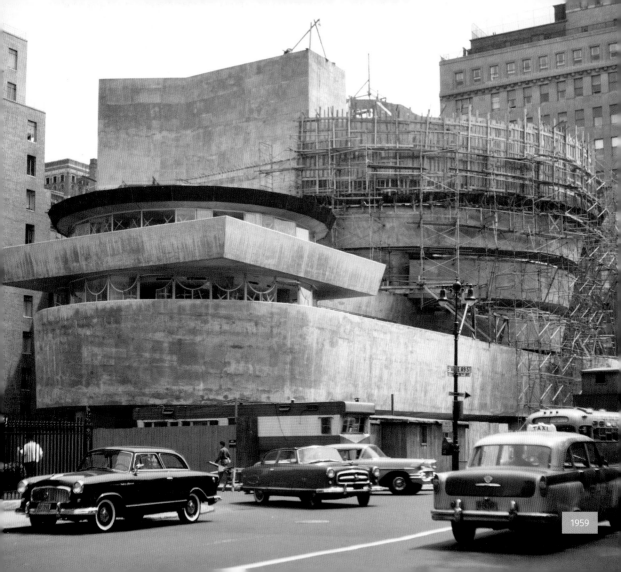

1959

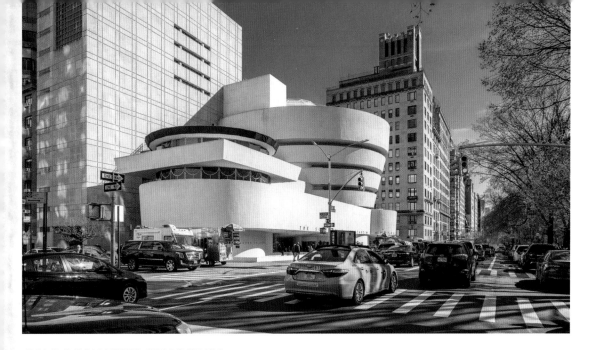

GUGGENHEIM MUSEUM

This unique exhibition space divided the art world when it opened

LEFT: The Guggenheim Museum (1959) is Frank Lloyd Wright's only major work in New York City, but without a doubt, it is his best-known building. At first, its famously free-thinking architect, Frank Lloyd Wright, preferred an undeveloped section of the Bronx so that he could spread the museum out like his Prairie Houses of the Midwest. But his patron, the copper mining magnate Solomon Guggenheim, had his heart set on Manhattan. Wright settled for this site opposite Central Park to allow some breathing room for his unique structure. His design, first proposed in 1943, also turned the art world upside down.

ABOVE: Before the Guggenheim was built, New Yorkers had never seen anything remotely like it, certainly not on elegant Upper Fifth Avenue where unadorned concrete exteriors had never shown their bare faces. The interior of the larger structure is a single large room where paintings are hung on sloping walls along a spiraling ramp. Wright believed that the continuous circular path, which begins at the top, was a great improvement over the multi-room route of traditional museums. But artists and art critics felt that the unusual surroundings would overwhelm the art. Today, the controversial building is recognized as its own work of art.

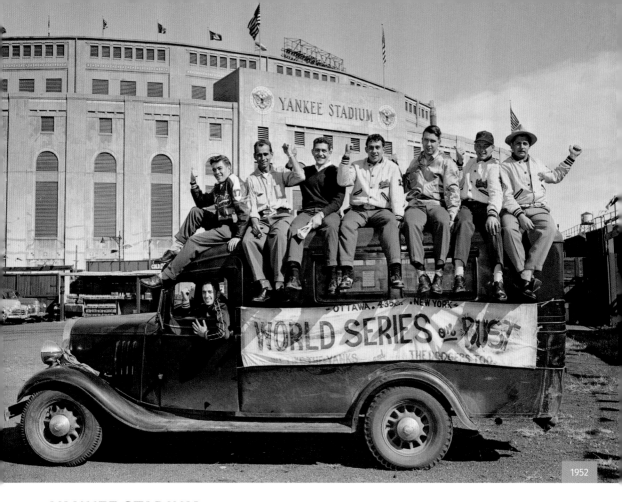

1952

YANKEE STADIUM

"The House That Ruth Built" was actually built by beer magnate Jacob Ruppert

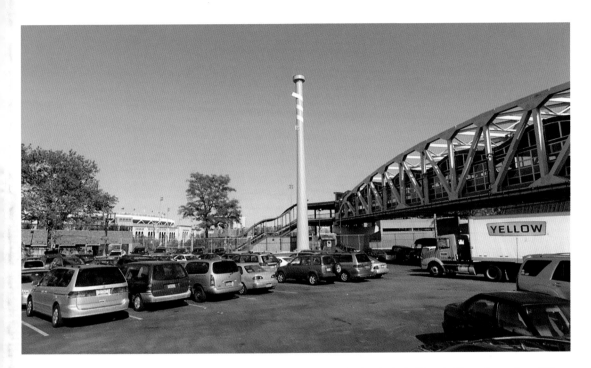

LEFT: Yankee Stadium was built in 1923 after the New York Yankees baseball team had shared the Polo Grounds with the Giants (baseball not football). Owner Jacob Ruppert found a site across the river in The Bronx and spent $2.4 million of his own money paying for "The House That Ruth Built." Legendary slugger Babe Ruth hit a rich vein of form in the early 1920s after starting out as a Boston Brave and in Yankee stripes he became the sport's biggest superstar. The photo shows Canadian fans who'd driven all the way from Ottawa to see a 1952 World Series game as the Yankees took on the Brooklyn Dodgers and won in a seven-game series.

ABOVE: The "Cathedral of Baseball" was in use from 1923 till 1973, after which the team moved out of the aging stadium while it was renovated and enlarged. Reinstalled in 1976 Yankee Stadium was in use till 2008 while a new state-of-the-art stadium rose next door on public land. The new $2.3 billion stadium included $1.2 billion in public subsidies and incorporated elements of the old Yankee Stadium, such as a replica frieze along the roof line. With the move completed, the old stadium was demolished and turned into a public park; the only lasting reminder was the 138-foot Louisville Slugger that stood outside the old site.

ALSO AVAILABLE **400-page Then and Nows**

ISBN 9781909108653

ISBN 9781909108660

ISBN 9781862059955

ISBN 9781862059948

ISBN 9781911595144

ISBN 9781910904817